We Were Taught To Plant Corn Not To Kill:

Secrets Behind the Silence of the Mayan People

by Tax'a & Douglas London

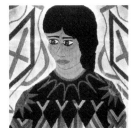

BACK UP BOOKS HUMAN MEDICAL RIGHTS PRESS

LCCN: 2006909158

ISBN-10: 0-9778104-0-2
ISBN-13: 978-0977810406

Dedication

To the memory of my father
Miguel Leon Ignacio
This book is for you.

Vulcanos of Peace

"Guatemala's towering volcanoes echo with the songs of children and the voices of the people, like the bubbling streams and songs of birds.

The woman who carries a child on her back, a grandfather who watches the planting of the corn. My people are my people, they rise with the sun, get on their knees to give thanks for another day, life and work passes.

In the night's fire, grandfather tells us stories of forefathers; there we find counsel and wisdom.

Grandfather has no fear of his advancing age or graying hair, his children follow in his footsteps, and he will always be in contact with them through the fires of the ceremony. In these flames of the volcanos of peace we see our past and future and accept our mortality as one of many. We are the corn, the earth, our future and our past."

Poem by Douglas and Tax'a

It is human to have hope and we still have hope for Guatemala. If there were no hope there would be no purpose to our book.

ACKNOWLEDGEMENTS

We would like to thank Reyes Tacam, Mayan Priest, for his spiritual guidance during difficult times in the interviewing process, Don Pedro, Mayan Priest for his spiritual guidance. Tax'a would like to thank Juan, Miguel, Mario, Estela, Loida, Lucia and her other seven brothers and sisters as well as her brother-in-law Juan Gabriel for their support for her work in times of hunger and danger. Douglas would especially like to thank his amazingly supportive mother Elizabeth London for all that she has done throughout the years. Tax'a would also like to thank her mother Juana Cortez Morales for her love and her courage, so humble yet with such a huge heart.

Additionally, Douglas would like to thank Phil Levenduski, PhD and the staff at McLean Hospital and Harvard Medical School. Also thanks to Darius Mehri, Sandra Acajabon, MD from Guatemala and Hector Lopez, MD from Honduras for their support.

We would like to pay special tribute to those children and adults who had enough faith in Tax'a to give their testimonies and paintings knowing that their words were going into a book that would let the outside world understand them better. We would also like to thank any reader that takes what they have learned from this book, even if the lesson is dark and difficult to accept and uses it to make the world a little better. Evil grows best in shadows, if we do not acknowledge the little bit of evil that exists in all of us we will never see tragedy coming until it is too late. This book bears witness.

MAYAB' TZ'ONOJ (Mayan Prayer)

!Lal Tz' aqol Bitol! !Lal Uj awila'
!Lal uj ata'! !Man ujayakanoq,
Man ujasachkanoq, Uk'ux kaj,
Uk' ux Ulew! !Chaya ri qa si'jal,
Qaxu'mal, chuwach ri q'ijsaq!
!Saqirtab' a chiqawach! Chaya ri
utzilaj qab'e, ri suk' qab'e!
!K'otab' a ri ke' menil kuk' ri
tinamit, etab'ari kiko'temal;
Chaya ri je'lik qak'aslemal! !Lal ri
Juraqan, Chip-Q'ak'ulja',
Rax-Q'ak'ulja, Chi'ip-Nanawak,
Rax-Nanawak, Uwoq Jun Ajpu',
Tepew Q'ukamatz, Alom, K'ajolom,
Ixpiyakok', Ixmuq'anek, Rati'Q"ij,
Rati'Saq! !Saqirtab'a ri q'ijsaq
Chiqawach!

- From the Pop Wuj (ancient sacred book of the K'iche' people)

TABLE OF CONTENTS

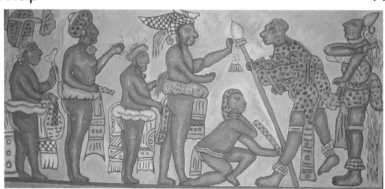

Rendition of Ancient Mayan Art by Mario Leon Cortez

Foreword

Humanity Cannot be Silenced

The Mayan genocide was a truly silent genocide. For decades, no one even knew that so many Native American Mayan men, women, and children had been brutally murdered in mass executions and that the Guatemalan death toll exceeded 200,000. Many millions more had been wounded, raped, and tortured, creating the largest campaign of systematic extermination the American continent has experienced in modern times. How can 200,000 people perish in an area so close to the United States -- only the distance from Maine to Washington, D.C. -- without anyone learning about it for decades? Only now the mass graves are being dug up.

The origins of this genocide started many years ago, arguably stretching back centuries. The most recent episode began in 1954 when a military coup overthrew Guatemalan president Arbenz, ending a period now referred to as a "brief spring" in a century of Guatemalan winter. Military officials replaced the president's democratic leadership, and violence became the method of choice. In the 1980s a small revolutionary guerilla movement located in the remote highlands of Guatemala – home to the indigenous Mayan population -- triggered fear of a Mayan uprising. The Maya, one of the largest intact Native American cultures left in the Americas, became the primary targets for massacres. The "scorched-earth policy," in which entire towns were burned to the ground and all their inhabitants machine gunned and buried in mass graves, left a death toll of over 200,000 victims and millions of refugees.

The genocide passed undocumented and its victims remained a secret until years later, when voices emerged, such as the Catholic Bishop of Guatemala Monsignor Gerardi. He documented the killings in a book called "Never Again." The day after it was published, the Guatemalan military assassinated him. Nobel Peace Prize winner Rigoberta Menchú, an indigenous Mayan, brought added attention through her book, *"I, Rigoberta Menchú,"* which highlighted the Mayan genocide.

What many do not realize, however, is that to this day Guatemala continues to grapple not only with trauma, but also with extensive violence directed at the Mayan people. Without recognizing the pain of the past, the future of Guatemala remains dark. Yet virtually the entire Mayan population still lives within a norm of silence.

The purpose of this book is to bring attention to the dire plight of today's Maya by detailing recent history. "We Were Taught to Plant Corn Not Kill"

is a courageous book about the horrors of the Guatemalan conflict. It is also a seed of hope in the Mayan struggle to preserve their culture amidst a backdrop of massacre and a norm of silence.

One of the remarkable aspects of this book is that a Mayan woman has interviewed the Maya in the Mayan language about their experiences of oppression and violence, and the people have opened up and spoken. This book offers first-person narratives about the extensive, organized violence against the Maya that is destroying the fabric of their culture.

I first met this book's authors at a course I teach at Harvard on the psychology of intergroup conflict. I had heard of the work of Tax'a' and her husband Douglas and invited them to attend. The class they attended focused on the causes and effects of violence from the perspective of perpetrator, victim, and victim's children. At the time, little did I know how relevant the class topic was to their work.

We met at a later date in my office. Douglas was animated and ready to take action. Tax'a' radiated an almost paradoxical character of intensity and innocence. She was quiet, listened deeply, and talked about her commitment to improving life for her beloved community of origin, the Kiche Maya. We spoke about their book - this book - and the major problems in Guatemala that it addresses: The cycle of violence and oppression toward the Mayan population, and the related erosion of Mayan culture.

I learned that, for Tax'a' and Douglas, this book is a personal as well as social mission. Tax'a's father, a Kiche Maya leader, was among the many murdered in a fresh wave of violence several years ago.

There is perhaps no better way to help Guatemalan society move toward reconciliation than to have national and international recognition of what is now happening. This can legitimize not the violence, but the fact that the violence is happening. Ethnopolitical violence is a group phenomenon and communal healing will involve all levels of Guatemalan society. The healing begins with a public awareness of the violations and a legitimization that wrongs indeed occurred and continue.

This book offers a Mayan perspective about the Maya rather than a Western anthropological perspective. It is as much an art book as a book about human rights. The story is told in equal measure in the artwork of Tax'a' and the Mayan children as in the interviews and narrative.

My advice to you is to let this book unfold. It is a profound poem, a historical document, and a personal biography. Nestled within stories of horror are

breaths of hope. Pictures of violence are illustrated in startling, vibrant colors that contrast the shadow of death with the light of life.

But this book is not just about Guatemalan society. It is about the courage to take action. Both the authors and those they interviewed have taken a risk by telling their personal stories of love and loss, trauma and truth. Through their courage, the authors and those interviewed teach us an important lesson: In the end, nothing can silence the power of humanity.

Daniel L. Shapiro, Ph.D.
Harvard University

Daniel Shapiro is Director of the Harvard International Negotiation Initiative based at the Harvard Negotiation Project at Harvard Law School and formally affiliated with the psychiatry department at Harvard Medical School/McLean Hospital. He is co-author of the bestseller "Beyond Reason: Using Emotions as You Negotiate" (Viking, 2005).

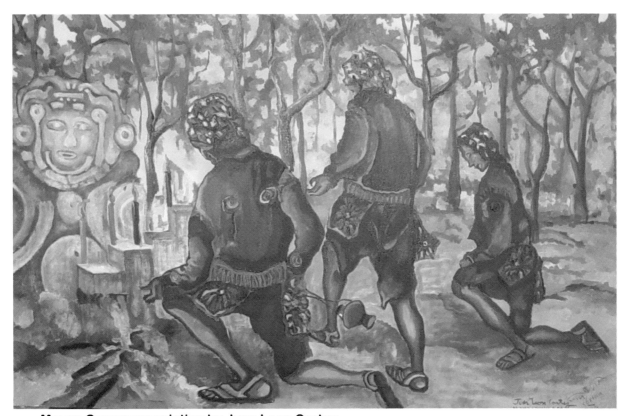

Mayan Ceremony painting by Juan Leon Cortez

SECTION I: MEMORY

WHY?

My father was murdered three years ago. I have 12 brothers and sisters. My father's leadership, faith, honesty, fairhandedness, love and wisdom were our family's lifeline during the genocide and all the years of local violence that have followed. My father is the reason we are such a tight knit family and have worked together to survive. Unlike most other families in our town we have not divided our land. It remains communal. We often have had no food and my father would do his best to bring home some bread, something to feed all of us. I appreciate the little things even a piece of soap or a pencil stub.

My name is Tax'a Leon and this book is about my family and my people, the K'iche' Maya.

I'm still waiting for my father but while I'm waiting I wanted to write a book to let him know that I care about him. A group of people killed my father and although I still do not know their faces, I know they are my neighbors. People in my town today can decide to kill somebody without fear of repercussions. Nothing was done to solve the murder of my father or the people that turn up every day in the cornfields machetied to death. Many women, even more than before, are found murdered in that way. After all the things that have happened to our family there are times when I feel fear and sadness and despair in humanity.

I wrote this book to tell people about the armed conflict that is still taking place in my country, Guatemala. Although the war has officially ended, the effects of the war are with my people, my family and myself today. The war is alive in the minds of those that went through it and echoes in their behavior towards their children and neighbors. This is one reason that the level of local violence has gone up.

People have trusted me and told me their stories. They told me with fear and anxiety in their eyes. Many of the people I talked to had lost their husbands, wives, brothers and sisters and sometimes were the only ones who survived in their family. Very few families in Quiche escaped the murder and death and trauma within their midst. The 1998 census statistics shows that the male population has not caught up with the population of women.

Opposite Page: "Witness", Weaving created in Chichicastenango in 1985.

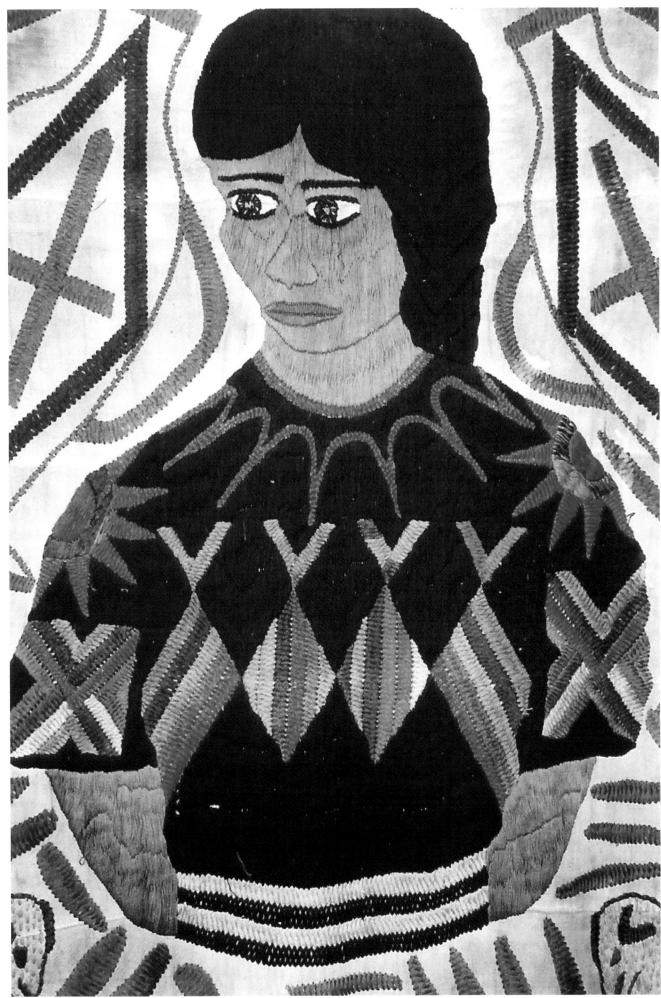

The interviews were conducted in my native language K'iche'. The testimonies in this book are the result of many visits with those who suffered in the war. It took a long time to gain their confidence even though I come from their culture and speak their language. The details of the artists and testifiers have been protected since the Guatemalan government can offer no meaningful security or legal protection from itself for its citizens.

The interviews were conducted while the people were going about their daily tasks. Some of the women were weaving while we talked. Some of the men were shucking corn.

The question that produced the most stark and truthful answers was "What was the pain that happen before?" or in my language " *Su ri q'uex xrak' tek ri ujer?*" This question often produced red faces and sprays of corn kernels.

I always asked them if they thought it was important to tell their sons and daughters and grandchildren what happened to them in the past. I wonder if their silence will protect their family or make them more vulnerable to the challenges of the future?

Painting is a way they could express how they feel without having to come up with words that consciously commit them to forming an opinion. Some of the adults that painted in this book had never painted before. Some people wanted a chance to verbalize what they felt, others were comfortable expressing their feelings through the artwork. Some things expressed are best left unsaid. Thus, both verbal and artistic testimonies convey what genocide does to those who survive and how the trauma can be passed to their children.

Some of my art student's paintings express their empathy with those in the United States that suffered in the massacre and destruction of the World Trade Center in New York. On the back of some of the paintings, some of the children put "no" to the US war in Iraq. These children are not expressing political opinions, they only hope that others can learn from their country's experience that starting a war and killing people is not right.

The lingering trauma does not come only from the families of the dead. Maya men were forced into Civil Defense Patrols under pain of death. They were compelled to do things beyond what their conscience could accept.

In Guatemala, we will continue with the same story because no one is willing to tell the story. The violence continues because no one remembers the past and our lips are sealed. We are afraid....

Opposite Page: "Eclipse" by Tax'a Leon in acrylic paint.

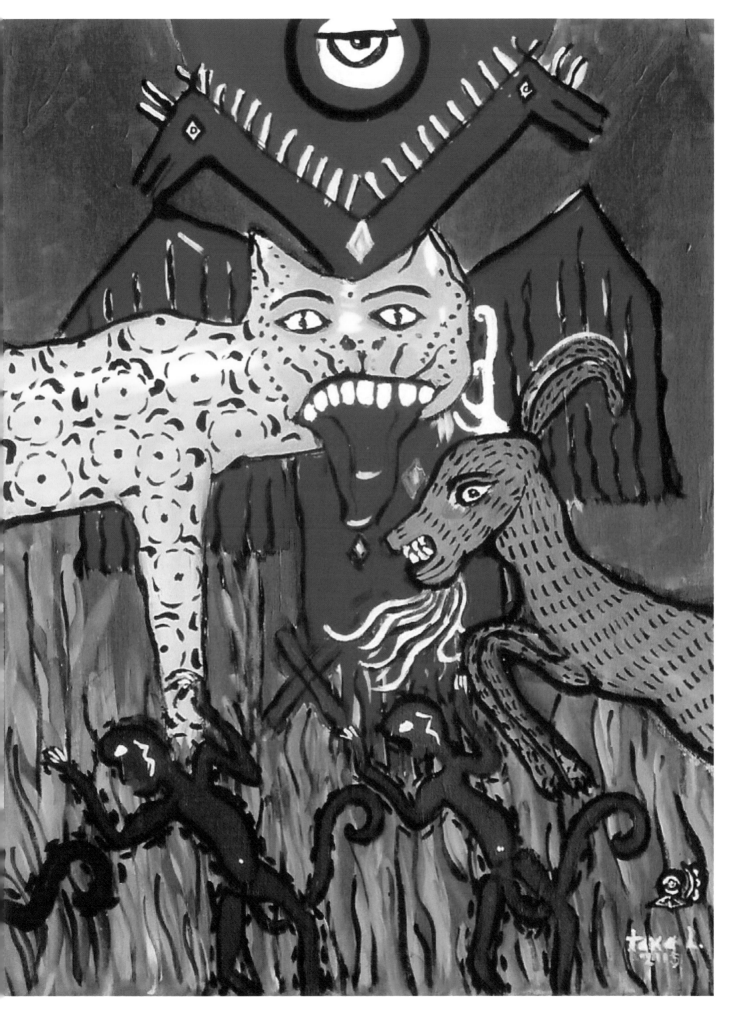

The danger has not gone away in 2005. One of the reasons I wanted this book to be written is because there is no communication about the war between the new generation and the people that went through this war. All that we learned through our suffering will be lost and forgotten if the story is not told. People without experience and knowledge are easily manipulated. Many believe the best way to solve a problem is to bribe, threaten or kill. In Quiche today there are lynchings and murders that never reach the newspapers in Guatemala, let alone the international newspapers. The politicians in my country can manipulate my people easily because the people do not remember or do not want to remember what happened.

Sometimes I despair that there will ever be any change in Guatemala. Some of the last paintings in this book include the "Vulcanos of Peace" and "Trensadores de Esperanza". My mother finds peace through weaving beautiful "Guipil" blouses for her family. These beautiful guipiles, with vivid patterns and brilliant colors, are what standout in the minds of many visitors to Guatemala. My mother works every day for four to five months to make a guipil for her daughters. We want the tourists to come to the highlands not just to buy our handicrafts but to learn about our culture and keep the eyes of the world on us. Witnesses make it harder for cowards to kill. This book bears witness. ------------ *Tax'a Leon , Santa Cruz de Quiche, January 2, 2004*

Below: "Dreams & Nightmares". Both by Tax'a Leon . Opposite page: "Ancestors".

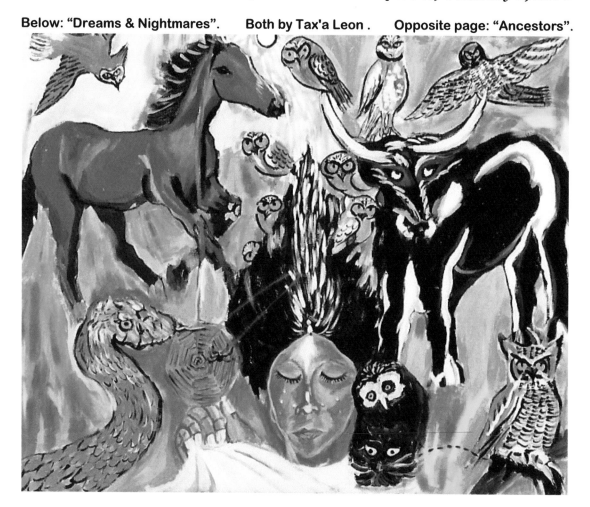

WHAT THIS BOOK IS ABOUT

There have been scholarly books written on the persecution of the Mayan people and the state sponsored violence in Guatemala. However, this book is designed to be more accessible to the general public without sacrificing the quality of precise, clear and unadulterated information. Opening up our own personal experiences, as well as those of the adults and children who agreed to participate in this book, is critical to give the right kind of communication to promote change in a way a third person, detached professional book cannot. We hope the format of this book will appeal to experts but also hope to attract the attention of those who would normally not read a book on this emotionally troubling subject. All testimonies and artwork are on an anonymous basis to protect the human rights of the testifiers and artists, an absolute necessity for this troubled region. Names where necessary have been changed to protect the innocent since the forces of evil are still at work in Guatemala.

Art not only keeps memory alive and accessible to all but captures the experience and the emotions that give memory meaning. The children, adolescent and adult paintings are from Tax'a's students and neighbors. This book outlines visually and through testimony the results of the violence that has devastated the K'iche' Maya, a group of over 1 million Native Americans who live in Guatemala. The K'iche' are only one of 21 Mayan language groups in Guatemala. Our book also describes the culture and history of the K'iche' and the causes of genocides and takes the intellectual risk of offering some solutions.

Art is a powerful way to bring value and meaning to a culture, society and way of life by showing rather than just telling the essence of trauma. Trauma is an emotional state where words usually fall short. In the second part of the book both art and words describe what it is to be K'iche' and a descendent of the great Mayan culture. There are reasons (besides ethnocentrism) why the Maya are not studied in public school by neighboring countries such as the USA and Canada. These reasons have a lot to do with the violent interaction between the West and Native Americans throughout the Americas. What happened to Native Americans in the USA in past centuries is occurring today in Guatemala. There is still time to stop the destruction of the Maya particularly if the citizens of the USA know and care to do so, since their government has played an intimate role in the tragedy.

The capacity of the Maya to suffer and remain silent never ceases to amaze and disturb us. Many visitors and even those foreigners working daily with the Maya on business and in development programs in Guatemala, never realize what is going on around them.

The threat of violence covers the past and leaves thousands of families covered with sadness and poverty, we are silent when tourists and visitors come.

Title: Nadie de Afuera Mira La Verdadera Guatemala
Artist: Juana Age: 19 Medium: Acrylic Paint

When state sponsored mass murder occurs in a country, the government responsible usually closes its gates to tourists. In Guatemala, the murder of a quarter of a million people over the last few decades was business as usual and the tourist trade has remained brisk. Guatemala has never been closed to tourism because there is such universal silence on the part of the population it has not been necessary to censor the population.

My wife Tax'a is a K'iche' Maya and comes from an ethnic group that is the subject of present day death and torture by virtue of being Mayan. It is her dream to convince her people to end the silence. Thus, "We Were Taught to Plant Corn Not to Kill".

Genocide is such a common theme in human history and occurs in such a diversity of cultures and situations throughout human existence on earth that clearly there is no one person, social class, race, religion, culture or political group to blame, it is in our nature as human beings. History is repeating itself with recent genocides in Rwanda, the Sudan and many other regions of the world as we enter the 21st century.

My family also comes from a background of genocide that destroyed most of its family members. My father stepped off the boat that had taken him from Indonesia to the United States as a Jewish refugee, after World War II. His only possessions were the clothes on his back including a worn and well used women's coat to protect him from the cold of the New York City winter of 1947.

His mother (my grandmother) had taken him and his sisters out of Nazi Germany at the last possible moment before the genocide started. The rest of our family waited too long and all perished in the Holocaust that soon followed. Good fortune did not follow my family to Indonesia where they fled. The Japanese invaded Indonesia and my father, my aunts and grandmother were interned in a Japanese concentration camp. At the end of the war only my father emerged, scarred for life but alive.

My father worked hard to forget and build a new life in the USA, working on the docks hauling produce and attending night school at City College to get an engineering degree. He became a scientist and even patented several laser applications for his company that are in common use today. But he never forgot. The effects of the trauma he suffered through personal involvement in two tragedies, in Germany and Japanese occupied Indonesia, were evident to those who knew him well.

Thousands of citizens have been affected in their own bodies and minds by the massacres, tortures and disappearances. Tears of suffering and pain still live in our hearts.

Title: **Eye**
Artist: **Augusto**
Age: **20**
Medium: **Oil on Canvas**
Village: **Chicua**

The legacy of these concentration camps has left me, his son, without one side of my family. I have only my mother's side of the family for living cultural reference. Being Jewish or being Mayan or any other race of persecuted people makes you aware of the underside of human nature. The Jews have made it a point to remember the Holocaust, a difficult but vital memory. Historical memory allows humanity to protect itself from its worst enemy, itself. As soon as the lesson is forgotten in our collective minds, we begin preparing the way for the next Holocaust. We are not protecting our children by completely hiding the existence of evil from them, we are merely making them vulnerable.

Only in extreme situations do humans demonstrate what they are capable of. The most shocking discovery is finding what lurks in our own soul. We need to remember and remind others that evil is something we are all capable of doing. We are all to blame. Blaming others is the easy way out and is the banner which politics, religion and law often appear to be written on. Finding someone to blame, rather than accepting our share of the blame, is a major part of social and emotional underpinnings and the justification of genocide. The realization that we all have a capacity to permit or participate in evil leads us to a fork in life's road, one way takes us on a journey to the land of denial where feelings of guilt and shame shroud our lives in uncertainty. The other way is clearly marked by signs of acceptance of our mixed nature and enables us to take responsibility for our actions.

I met Tax'a when she was giving a speech dedicating a human rights mural painting that she had organized for K'iche' Maya artists in Guatemala. In 2006, the mural still stands as a testimony to the trauma of the genocide her people suffered through. This trauma has sent a shock through Guatemala which has become desensitized to murder and torture techniques. These techniques have been passed from the Guatemalan government (and those who trained them), to the people themselves as the country is being ripped apart with violence.

Today the Maya face a problem more serious than ever before. The 2000-year old Mayan culture is in danger of disappearing in the next few decades under a wave of violence and racism. The Maya need international help. This book gives you the Mayan story. It is up to the reader to decide if they want to get personally involved. Those interested in learning more can visit our web sites.

www. brainrights.info or www. mayanflamegallery.com

-- Douglas London

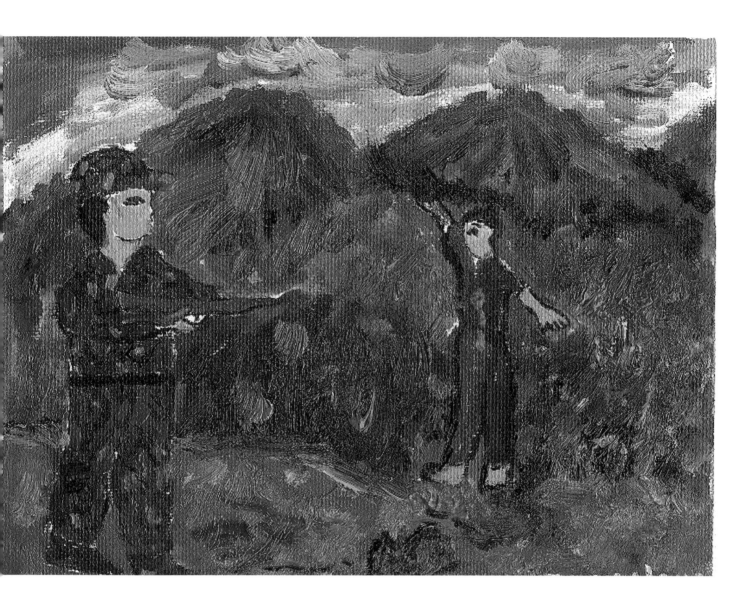

Don't kill me sir, what have I done, I have a family that needed me.

Title: **Last Words**
Artist: **Tomas**
Age: **18**
Medium: **Oil on Cloth**

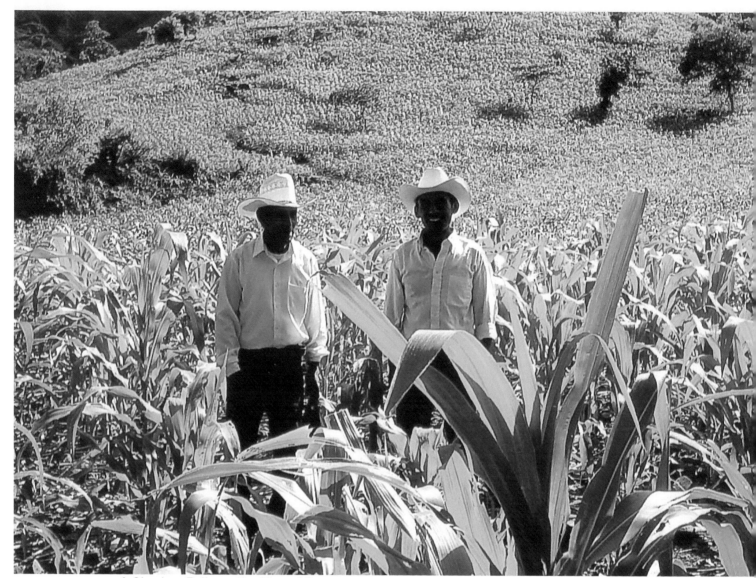

A Shadow Falls on the Men of Corn **photo by Douglas London**

Serpent Belts
by Taxa Leon
In acrylic paint

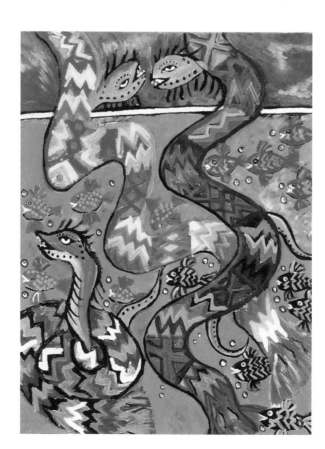

TRAUMA

This book is a symbol, in art and words, to remind those who know to inform those who do not. Look carefully at the paintings and stories in this book as they represent the worst side of humanity, which although we may deny, lurk amid the good that we all have. Guatemala is a land of extremes that has laid the soul of humanity bare and naked for those who care to see. This is a sad tradition of a country that despite modern trappings has many aspects of the medieval system of feudalism, forced labor and enforcement of societal norms primarily by threat, murder and violence.

The torture and suffering and pain endured was one of the strategies of the war, pounding and hardening the hearts of the women, men and children and creating a population full of bitterness, hate and trauma. Malnutrition is mixed with murder, illiteracy is mixed with fear. Trauma and shame are among the traits inherited by the artists and those who give testimony in this book.

The murder of over 200,000 of its own citizens over the past few decades reaches a pinnacle in the genocide of the Highland Maya, centered in the Department of Quiche (K'iche'), during the period from 1978 to 1983. The mass executions of entire Mayan town populations and the exodus of a million Mayan refugees are all the work of their own government, United States military support during the Reagan/Bush administration and sometimes their own neighbors. This is the legacy of the K'iche' people today and is reflected in the art and testimony in this book. The societal trauma has affected almost every family in Guatemala.

This book tries to weave a story out of a tragedy to convey a message that is classical in the sense that it plays itself out over and over again in the history of different countless nations, political situations and cultural contexts throughout human history. The theme of trauma and its expression is part of the collective psyche of Guatemala, a region that has for centuries endured suffering passed from one human to another, for motives of personal or class gain. This book is not a judgment of individuals or groups, it takes a certain social system to bring out the worst in human beings and Guatemala has been locked in such a system for centuries. If the tables were turned, who is to say whether the victims might or might not act as their persecutors did? There is a little of Guatemala in all of us.

Connections between historical and present day events are often not taken into account by the population that is alive today. The connection between generations is often not part of the consciousness of the newest generation. But unconsciously, history plays a significant role in determining the traits that are passed on to an individual and society. Again, this book is a symbol in art and words to remind those who know to inform those who do not.

WARNING

"One day, Sunday, a group of coyotes appeared howling, moving from place to place, sending a warning in the middle of the night. Many people woke up afraid and others curious but the danger was coming closer to town.

My people thought that it was a disease that was coming but it was much worse, people were massacred, tortured in a very cruel form. In my community they took 74, some women and children, saying that they were part of the guerrilla movement. They took them into the mountain. There the massacre was cruel, what happened to the entire town, we couldn't leave. In my house we suffered from hunger, fear, many people became ill because of nerves and sadness and because there existed no hope."

Testimony: Miguel
Age: 54
Village: Panquiac

Our grandfathers tell us that when coyotes appear in sacred places something unexpected is going to happen, that difficult times are approaching, an epidemic, a natural catastrophe, a dangerous time in which many people will die. As a sign of the times of violence to come in the years of the 1970s and 1980s, coyotes appeared on the steps of the Church of Santo Tomas Chichicastenango, a sacred place for the "mashenos" or people of Chichicastenango. In the colonial era the Spanish built a church in Chichicastenango over Mayan ruins. Many believe these ruins were once a sacred ceremonial center.

Opposite page: "Warning" by Tax'a Leon in acrylic paint

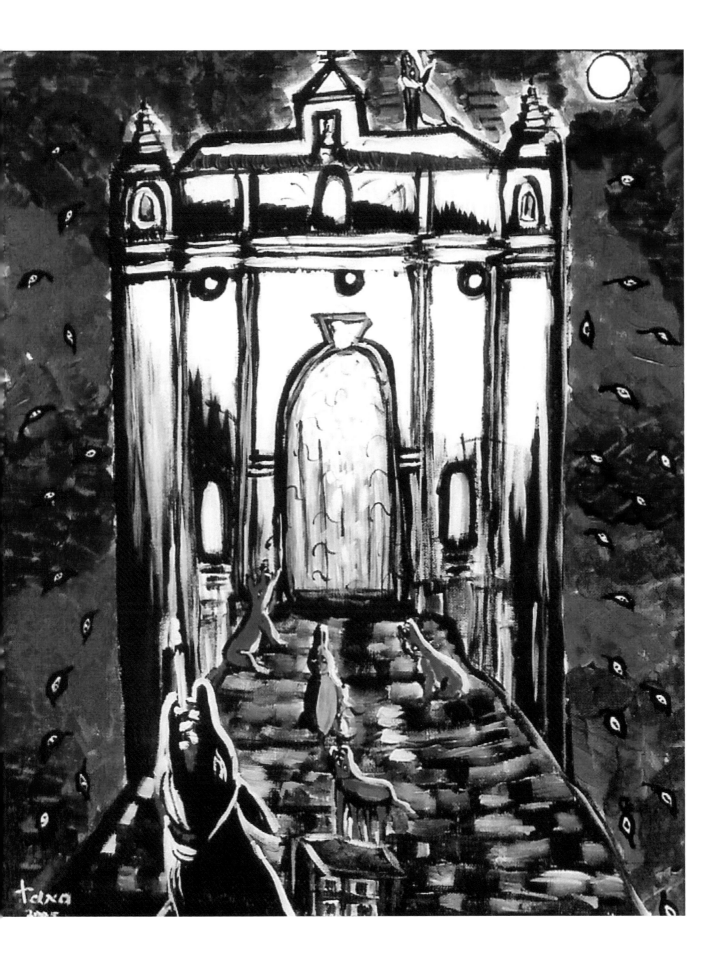

INNOCENCE

"In the days of violence, I washed clothes in the town. One day, when I was coming back from washing clothes, I heard the sound of a whistle and heard people say that this afternoon they were going to come and give away balls for the boys and dolls for the girls. The parents were unsure, but the children insisted on going to receive a toy and for this reason that afternoon they arrived, dozens of children accompanied by their mothers, children that came very happy because the poverty was such that many children had no toys to play with.

That same afternoon army trucks arrived carrying soldiers. When they gave out toys, they asked the children the name of their parents and if the name was on a list they carried, they took the boy or girl and hit them hard with a shovel on the ear [a fatal blow] and threw them into a hole that they had prepared. Upon seeing this, the fathers began to beg for pity for their children. Many fell to their knees and implored mercy for their children. But instead of listening to them, they were killed in the same way as their little ones. Many mothers wanted to run away with their children but they couldn't escape. The soldiers had made a circle around everybody there that afternoon and everywhere there were cries of terror. They were all killed. I was going to go with my children that afternoon, but thank God we were delayed. We had started going out on the road where we were going to meet up with everybody but far away we could see and hear it, the screams of the children. We hid in the bushes until the soldiers left, upon sunrise the next day we casually walked out of our village like nothing had happened without taking anything, only the clothes we were wearing. We rented a house and somehow managed to pay for it, although there were many times that we are unable to eat. But this was not important because I had my children alive at my side.

We returned to our house a few years ago and found the house full of weeds and bushes, the doors of the house were opened, the dishes in my kitchen were thrown on the floor. More than 12 years after we left our house I found out they [soldiers] stayed in my house and I can still see the chicken bones that they left in our house. In those days the soldiers killed people and ate in my house."

Testimony: Juana
Age: She is not sure of her exact age, thinks about 64 years old.
Village: Xepocol

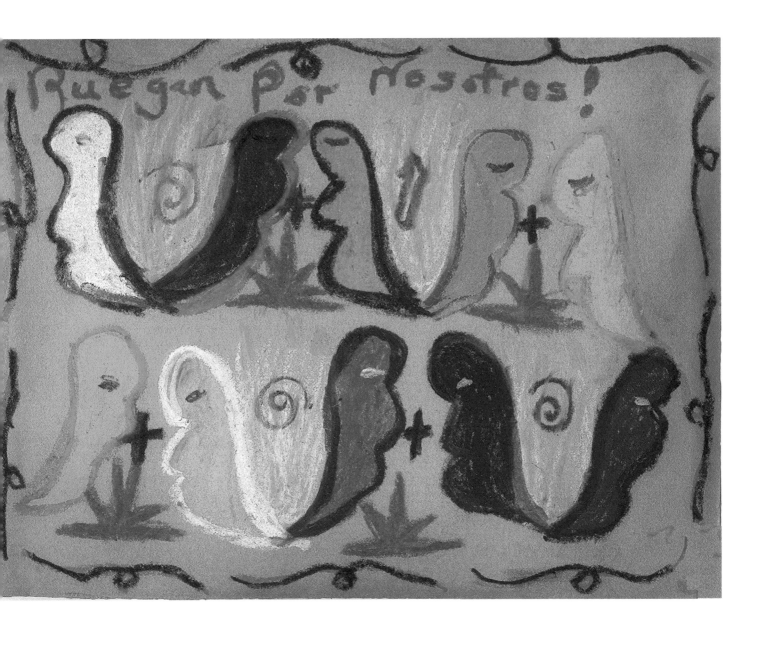

The angels, the souls of our grandfathers, protect us, pray for us, for our safety.

Title: **Ruegan por Nosotros (Pray for Us)**
Artist: **Maria**
Age: **12**
Medium: **Oil Crayons**

TESTIMONY OF TWO SISTERS

"Both my sister and I were born in Chontola but because of the violence in the 1980s we had to flee until we arrived in the town of Chichicastenango. We found a ranchito where we stayed with our father who was very ill. People told us that our town, Chontola, had more dead every day, many people and entire families died in this time and all that remained were the widows and orphans. The canton [Chontola] stayed "enlutado" [covered with sadness] with so many family members dead. We were lucky enough to move to the town. My father lived but even there [in town] many groups of people passed in lines with the soldiers in the night and all we heard was the noise and the screams of them and the howling of the dogs and they did not come back.

One day, Thursday, I went out to buy a little sugar and I saw three men with hats shoot a man near the town hall. They shot three bullets and then fled, after a little time, a group of soldiers arrived and saw the man lying there and asked if anybody had seen this. Nobody said anything, nobody could say anything.

My sister and I abandoned our neighbors and never went back to Chontola. The people in town [Chichicastenango] are afraid of us even today because they think we were part of the guerrillas and there is still fear here about us. They don't allow us to come into their homes. There will never be a sunrise when we will live in a decent house, we will die alone, in the drops of cold, in the ground."

Testimony: Tomasa & Manuela
Ages: They do not know their ages, they think both mid 70s
Village: Chontala

Tomasa and Manuela live in a house made of corn canes covered with plastic bags. The rain was entering and they were cold when I interviewed them. Like many of the women that were forced to leave their villages in the war, they settled in another place. These two sisters never married. Now they are old and all they have is each other.

Opposite Page: "Widow" by Tax'a Leon in acrylic paint

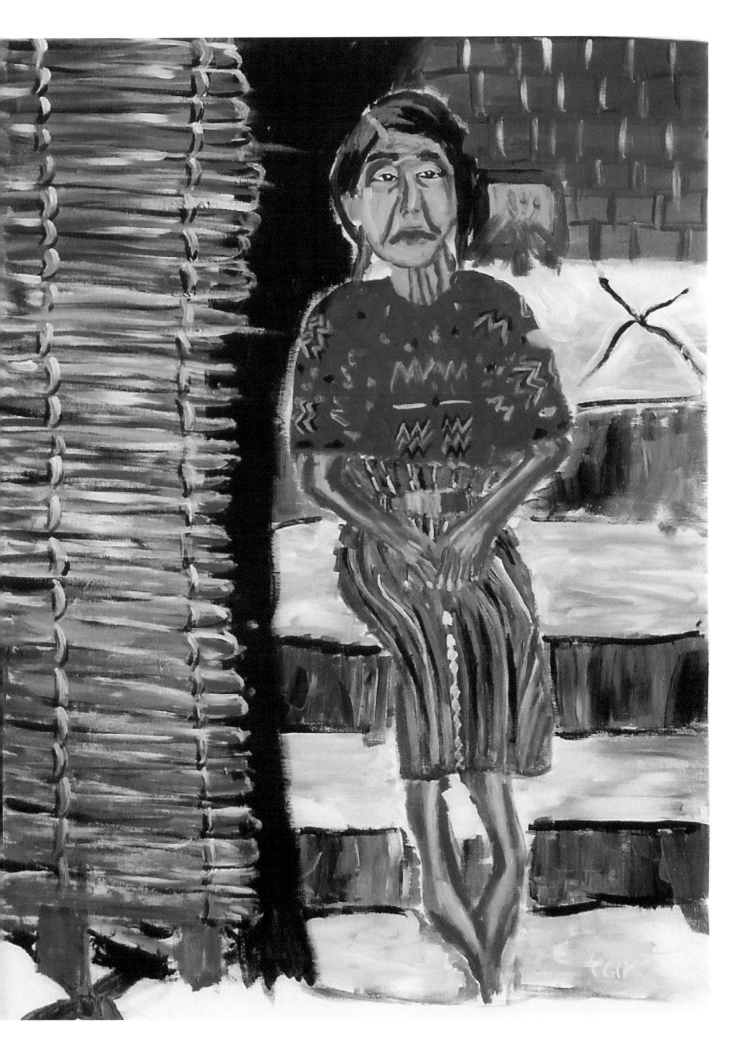

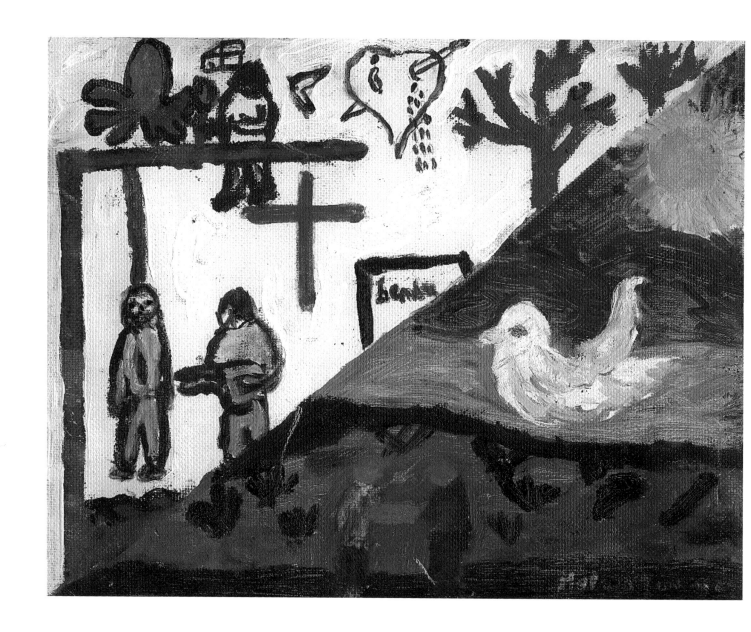

The army controls our country, we all want our rights so that
Guatemala can straighten itself out with real hope and light.

Title: **Las Dos Caras de La Moneda**
Artist: **Melvin**
Age: **14**
Medium: **Oil Paint on Cloth**

BRAIN WASHED

"My three friends, Maria, Manuela and I, we were 17, 16 and 18 years old and we liked the parties. One day some friends invited us. They invited us to a meeting in a place called "Los Encuentros". We went. We got to a room where we saw a lot of young women and men and leaders and the mayor Tomas T. was there also. They said we had to fight for our rights, for equality, that everybody has a head, hands and feet to defend themselves and we should stop being ordered about by the "Ladinos".

Afterwards they welcomed the three of us into their group, then came the time to leave and we made an agreement to meet again and they said to say nothing about this new meeting but they would know if somebody said something. Later they started to form a group of leaders of young indigenous women and men and teach them how to hold arms, to run, to shoot.

As days went by more persons participated until one day when we heard on the radio they had killed Tomas T. The army started to look for the people that belonged to the guerillas. The three of us were scared. One day Maria and Manuela came to talk to me, they were looking for money to go to the United States. Many people had been killed. They went. I stayed. Most of the guerilla leaders left for Mexico or the United States. Most of the "campesinos" stayed because they had families here and no money. I know my family never knew about these meetings because they were secret during this time. Afterwards I married. Now I think that the "campesinos" that were killed were innocent and were brainwashed and used by both the army and the guerilla groups. I am one of the survivors now."

Testimony: **Sebastiana**
Age: **43**
Town: **Chichicastenango**

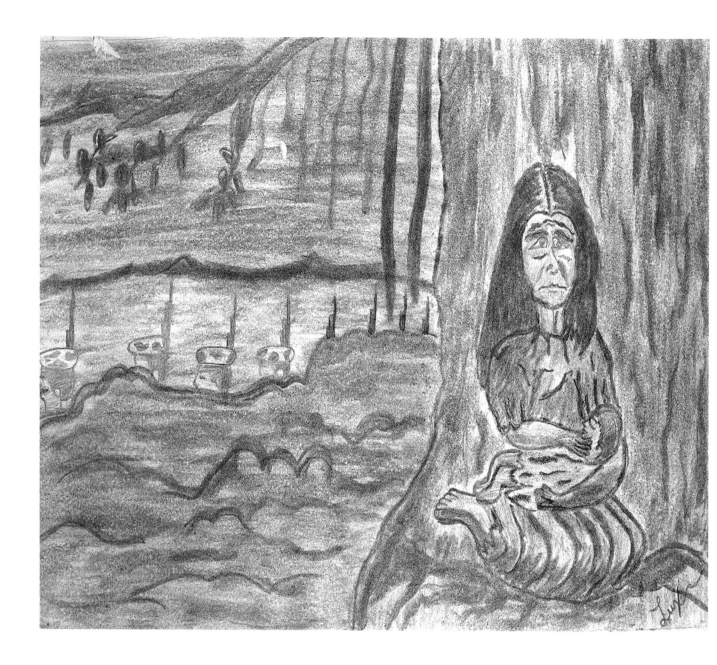

The woman in this painting was captured by the Army in 1980 near her village in the region of Ixcan. Several days after walking with the soldiers and other village members with hands tied in the mountains, she escaped with her three month old baby by jumping off a cliff. This woman and her baby were close to death from injury and thirst in remote mountains when she was found by a group of refugees. She and her baby survived the war.

Title:	**Refugee**
Artist and Interview:	**Lux**
Age:	**42**
Town:	**Nebaj**
Medium:	**Pencil**

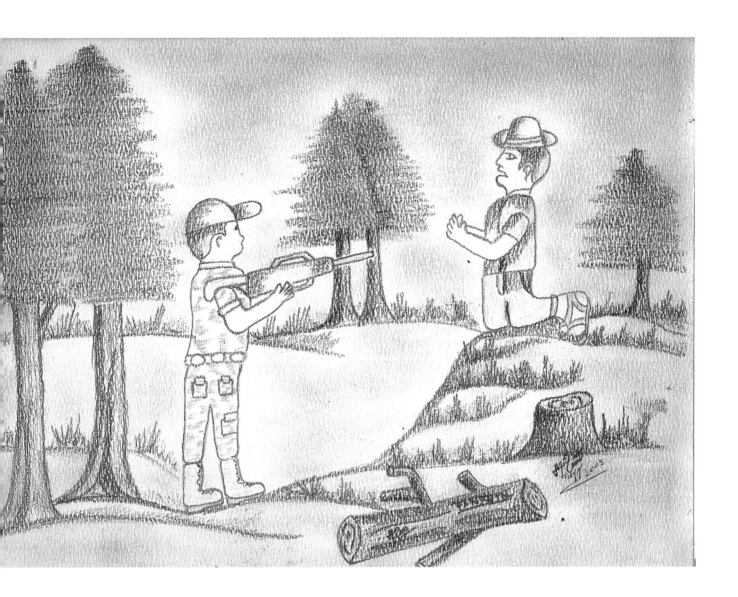

TAKE PITY ON US

When the night destroys the day, the clamor of those who are alive matters
not. Only the earth can tell us the real truth and she stays in silent testimony
over the darkness of our lives and interests of states and powerful nations
meddling in our country.
They incite battles between brothers which ends in hunting us down as
though we were wild beasts in the mountain.
Nature takes charge, guarding within her breasts the bodies of many of her
innocent sons sacrificed to further the gains of the politicians in power.

Drawing and Poem by Marcelo, age 37.
Medium: Pencil. Town: Chichicastenango.

MEMORY

"I didn't know anything about enjoying childhood because I was a boy condemned to work and watch the others play with their friends and their parents. It was wonderful to watch that but also sad because I was not included. Now it makes me afraid to grow older because if I become a man I'm going to do bad things like the things that they did. I prefer not to grow because this implies doing much harm to the people like killing, robbing, falling into corruption. Better not.

According to my mother and my brothers, my father disappeared in the time of violence. I was a boy of seven, when one afternoon I saw some soldiers hitting my father without mercy. The cries of my mother on seeing this stay locked in my mind forever. Sometimes I wake up in the nights hearing these cries. In these moments I don't understand anything. Of my father I only remember the color of his clothes and a tender look that he gave me while they were hitting him. A short time after he was tied up and taken with the other men and when they were tying him up with a rope he turned to look at me and the look he gave me was the last thing I remember about him. Maybe he was saying goodbye.

Now they talk about peace and more peace. I don't see the connection because for me this peace agreement doesn't exist. It doesn't exist for those who govern us, it could not exist if the most famous mass murderer washes his hands with the blood of my people and then dries them on the flag of my country. He holds important positions from which he tries to fool us, to cover his shame with gifts and machine made talks as he pleases. In his conscience there is a corner in which thousands of victims are calling out against him for what he has done to us.

In my town they celebrate a lot of important dates, I believe the celebrations may only mask the fear that we still have hidden in our minds. The fear does not want to go away because every day violent acts are repeated. Every time I hear this [violent acts], the images of my childhood come back like an invulnerable ghost that makes me feel compassion for the children. The orphans and the widows will suffer together for the rest of their days because to grow up without a father is a very hard life because all dreams of peace and of improving yourself disappear."

Testimony: **Miguel**
Age: **32**
Village: **Chulumal**

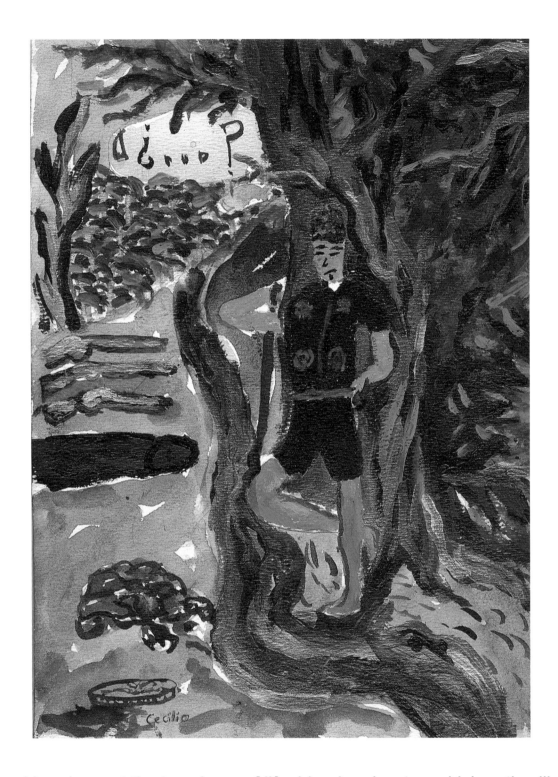

Looking down at the two rivers of life, blood and water, which path will
I choose when they divide?

Title: **The Tree of Life**
Artist: **Cecilio**
Age: **16**
Medium: **Mixed watercolor, acrylic and oil**

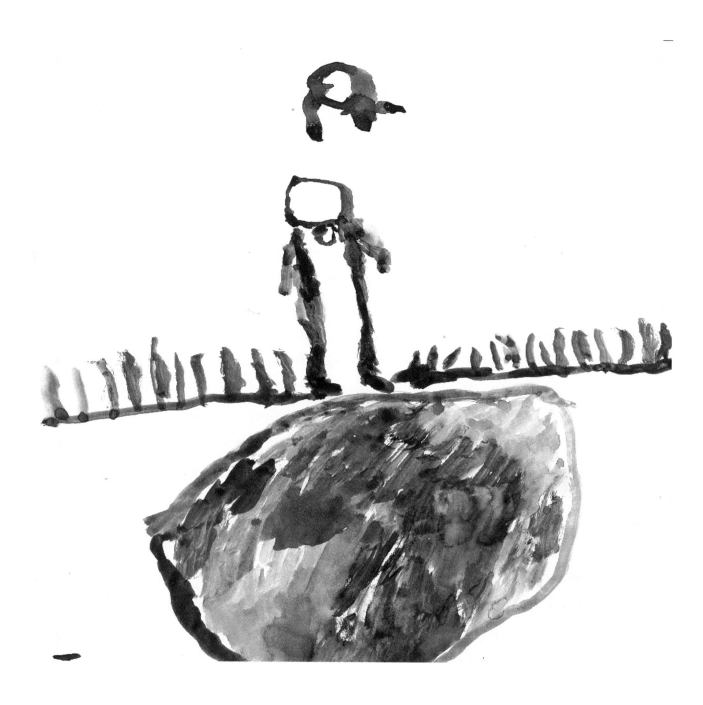

Title: **Secret Cemetery**
Artist: **Tomasa**
Age: **70**
Village: **Chontola**

FORGETTING

"In my community in the 1980s they forced us to patrol. We were children of 14 years old, no one could hide from them because they had a list of the community. At the beginning it was tranquil. But soon a group of soldiers came and forced us to answer questions such as who belonged to the guerrillas. They put us in a circle and no one said anything. So they asked us if we wanted to keep patrolling and all said yes. Then they gave us arms and said that if we saw a group in the night we should shoot them. The ones that had no guns carried machetes and shovels. They divided us into groups each day and they said things so many times to us, to the point that we had to obey their orders. They obliged us to shoot our friends and if we didn't do that, we were dead men. Thinking of your family, you want to stay alive.

These memories are always in my mind and I can't erase them, what happened I have never been able to understand. Many times I get drunk to forget this nightmare. Now I'm with my family and I try to forget sometimes what comes over me. I pray pardon for those that are dead and those that I have seen with my eyes and couldn't do anything to help them, in my past. And like a martyr today you don't forget, ever. Each time I see a person with a gun in his hands that is the person that damaged the life of a family. I can't get it out of my mind because it's in my memory. I cannot forget."

Testimony: Jose
Age: 41
Village: Salbaquiej

PERSECUTION

"In my community there was an understanding that people should meet at the sound of a whistle. The military took advantage of this to gather the people from our village. On various occasions armed men arrived with "fusiles" [often pistols], shovels and lists of suspected guerrillas. No one from the community ever admitted to being a guerrilla even though the army said they were only asking the guerrillas to apologize for what they had done to the people.

But one night, Wednesday, almost sunrise Thursday [morning], they gave the order to gather all the people, including the elderly and children. Those in charge of rounding up the people were the Civil Defense Patrols. When they had all the people together, they made a circle so no one can escape. It was horrible.......

That night the soldiers made a circle in the dirt and took out a huge list and called those on the list. They called a total of 70 men, most did not know why they had been called. The soldiers told the people gathered that these men were guerrillas and they were not willing to confess when they had had the opportunity, but their time was up.

Those people were grouped together 10 by 10. They put them to work digging huge holes in different places. When they had finished the holes, sons and wives were made to stand in front of the condemned men and the soldiers grabbed them one by one and gave them tremendous blows to their bodies. When the person was in absolute agony, they gave them a heavy blow on the ear [a fatal blow] and threw them in the holes.

The cry of the women and children was frightening. Some children cried without stopping. Others couldn't cry.

After the execution, the soldiers and Civil Defense Patrol members began to cover over, or better said, to throw dirt over the bodies. It felt like it was happening to those of us watching, that we were being buried alive. That is what I saw and that is how I feel when I remember."

Verbal and Painted Testimony (opposite): **Jeronimo**
Age: **54**
Village: **Paquixic**

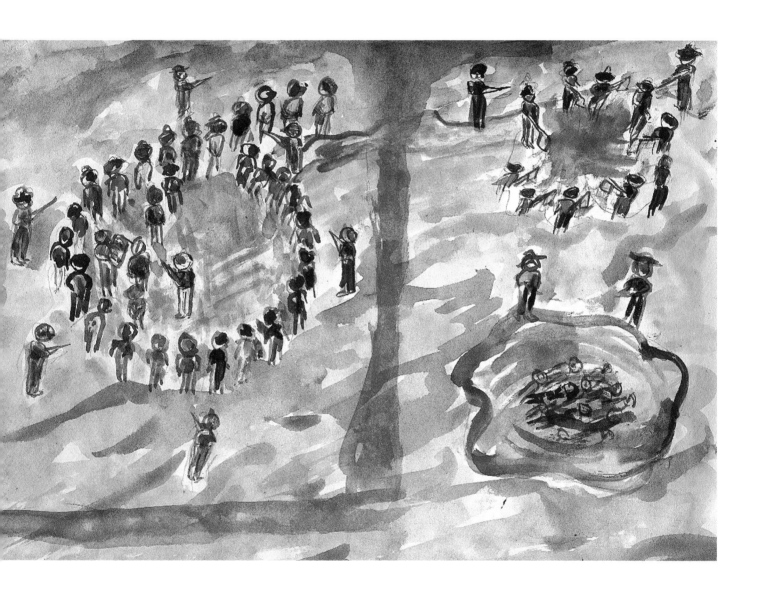

Title:	**Persecution**
Artist:	**Jeronimo**
Age:	**54**
Village:	**Paquixic**

LINE

"In the year 1979, I had a little store that sold basic goods on the side of the road. In the beginning, I believed what the soldiers said [about the war] because they passed by my store without causing any harm. Then one day they began to throw everything out of the stores and if they found someone in their way who tried to block their entry, they killed them and their family. One time I was standing in the door of my store, when I realized that a line of men dressed in green was approaching from a distance. I became very frightened. I thought about running from the house with my children but I remembered that that would be worse. Instead I hide under the table and that was how I saved myself. The soldiers came in with arms in their hands ready to kill anyone who moved, but I did not move.

My brother Miguel was kidnapped by them [the army] along with his wife. Many times my brother was called by the patrols [Civil Defense Patrols] to present himself voluntarily but because he didn't do so, they took him by force. I ask myself sometimes if he is alive or not. I keep the conflict inside me every day thinking about them and where they are.

I believe that it is not over, every day the story is repeated in our country. The authorities could control it but it is they who taught us to rob, to kidnap, to kill."

Testimony: Sebastiana
Age: Not sure of her age (she thinks she is about 81 years old)
Village: Chilima

"Prey" by Tax'a Leon in watercolors.

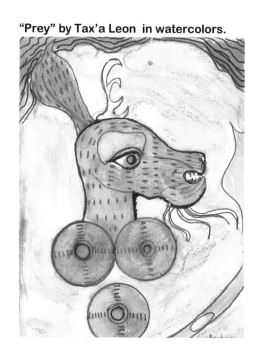

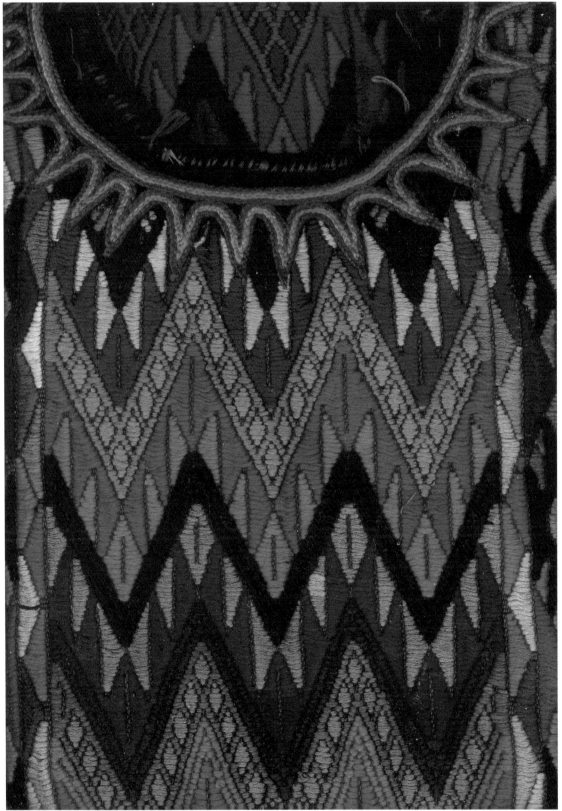

K'iche' guipil from Chichicastenango. Photo: Douglas London

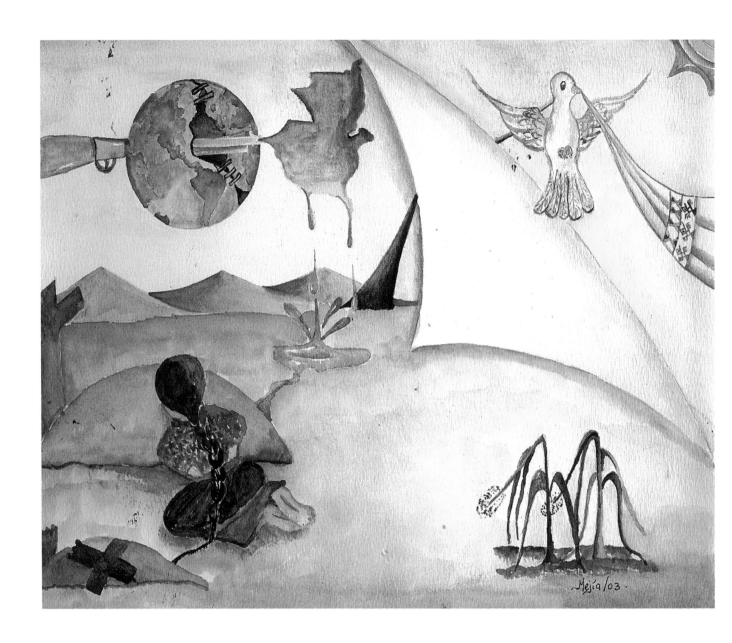

EVERY CENTIMETER OF LIVING EARTH REMEMBERS US FOREVER

In the world we have been given, there is a continuous war between brothers, all for the false peace which they come to offer us.

Powerful nations, our country cannot be saved by confronting them. Until so many innocent are dead and have had to cry, spilling the blood of our nation.

Holding on to those harsh moments, they have fallen without a cry.

Living during hard times sharing pain with our mother earth who protects us in times of pain for the loss of her sons, who have no real peace, just dreams offered to us that are not real and every centimeter of living earth remembers us forever.

Poem & Painted Testimony: Mejia **Age: 35**
Town: Chichicastenango **Medium: Watercolors**

SCHOOLS

"Since people were brave enough to give their own testimonies for this book, I realized that I needed to find the courage to give my own testimony.

For my first five years, I went to a little school where they only spoke my native language of K'iche'. In my sixth year I had to go to a school where only Spanish was spoken. I did not speak Spanish and the teachers made no effort to help me understand what was being taught. When the teacher gave an assignment in Spanish and I didn't understand it, that was my problem. If I came back to school with my homework done incorrectly, the teacher would take a ruler and hit each hand 20 times. I came home from school many days with both my hands raw and red from the teacher's beating. I wasn't able to pass the classes and had to stay in the same grade because I couldn't understand what the teacher was saying. Most of the indigenous students suffered as I did.

At the beginning of the next school year the teacher asked one of the boys to peel back the fibers of a plant then put it over a fire and harden it. For many days the teacher would whip my hands with this branch until they were raw. He would say you must learn to do your homework but I couldn't do my homework because I couldn't understand what they wanted me to do and they would not explain it to me. In school, as little children, the teacher made those of us that could not speak Spanish stand in public in a group and they put a sign in front of us saying "these children are lazy" while the other students and adults laughed at us and we felt ashamed. That is how they forced us to learn Spanish and taught us to be ashamed of the fact we were Mayan.

I was one of 13 brothers and sisters so there was no money for all of us to have pens and notebooks. So I went to school with nothing in my hands. I had no way to write down anything, no way to study. My father never lost faith in me and told me that someday I would pass the classes. I repeated that grade for 3 years. I managed to pass in my forth year. Only the faith of my father made me able to suffer all the abuse and shame. The school taught me to be ashamed of being Indian, being poor, not speaking Spanish and ashamed of being a woman. If you ask why my parents couldn't intervene, you are far from understanding reality in Guatemala.

Many children in the highlands do not finish school because they would rather not be beaten, abused and humiliated. They prefer to leave and live the rest of their lives without any education."

"Indigenous Guatemalans have a very high illiteracy rate, not necessarily because they have no desire to learn to better themselves but often because the school system can be brutal.

Many people cannot even sign their own names on a document. They can only leave their thumbprint or fingerprint. This is a source of shame for most of them. You suffer humiliation going to school and you suffer humiliation afterwards if you don't go to school. Either way you come out feeling ashamed.

I have been told by older friends that it was even worse 10-15 years before, right after the genocide. Many of these former students say that they were hurt and humiliated so much by their teachers, that as adults decades later they cannot bear to look at their teachers as they pass them in the road. Even after all this time, many have expressed to me the desire to strike and hurt these teachers for the shame and humiliation they forced them to endure.

So the school systems teach us bitterness, hate, and to hide our feelings completely. They instruct us in violence as the way to get what you want from life. Even after school, the lessons in violence continue. Most indigenous women are reluctant to get a job because bosses in many companies, as well as households that employ indigenous servants, routinely practice sexual harassment and even rape on their indigenous female employees.

This is but one example of what lies behind silent eyes in Guatemala.

Eventually I went to the university. I decided to study law so that I could protect my family and myself."

Testimony: Tax'a Leon

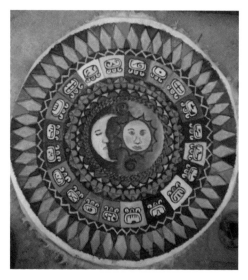

The Twenty Mayan Nawals:
B'atz', E, Aj, I'x, Tz'ikin, Ajmaq, No'j, Tijax, Kawoq, Ajpu', Imox, Iq', Aq'abal, K'at, Kan, Kame, Kej, Q'anil Toj, T'zi'.

"Mayan Calendar" painted by Miguel Leon Cortez *Opposite*: Mayan Handwoven Clothes

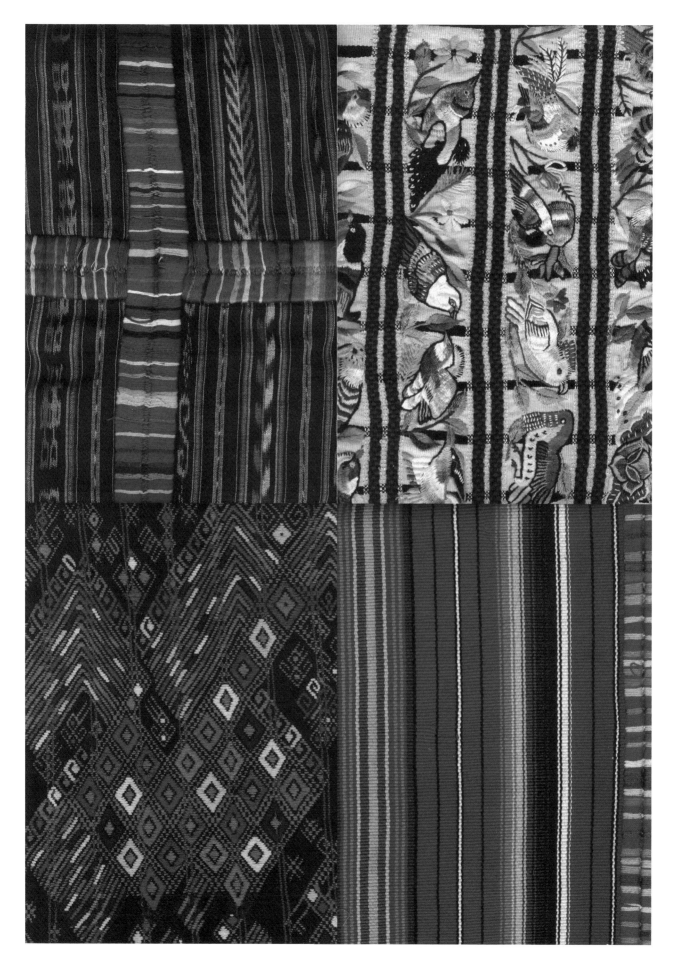

45

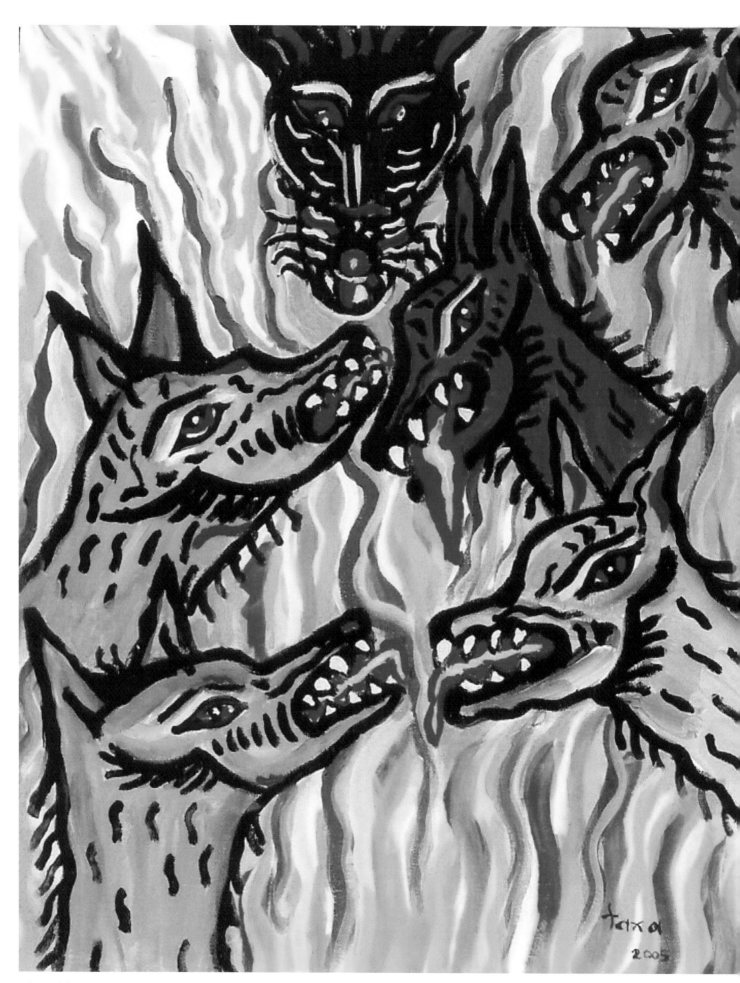

Lynching by Tax'a Leon in acrylic paint

46

LINCHAMIENTOS

The internal problems provoked by the Guatemalan civil war are described to you through the testimonies in this book. We noted the suffering, the horrors, the persecution and the victimization of many people, villages, towns and households scattered in the mountains. I recalled a part of my childhood and wrote the following in my diary after a discussion with members of the villages Xalbaquiej and Paquixic, Chichicastenango in 2003. In these villages, on September 4, 2002, people were tied up, had gasoline pored over them and were burned alive. This time the incident received some attention by international journalists.

"As a little girl I (Tax'a) watched a group of soldiers shoot and kill a man from the window of our house, I remember him rolling and rolling down the hill into our cornfield. I remember my three uncles and my grandfather who were killed during the genocide. My example is typical, our people are accustomed to murder. The lack of legal recourse and indifference to the law has reached such an extent that those who rob, rape or kill, are able to avoid justice and there is rarely any investigation to discover who is responsible. The break down of the legal system affects the nation, local community and family structure. Those who commit crimes are not punished, creating resentment, and allowing a minority of those who are comfortable using violence and the threat of it, to manipulate the majority.

Thus, the lynching and murder by people who have taken the law into their own hands are examples of what the people know best, that is the actions of terror taught by our Guatemalan army. These ruthless rituals physically and psychologically destroy society. We have become a culture of death, fear, panic and indifference, where man loses his reason and uses his darkest internal resources. He becomes a savage beast.

The violent consequences of the genocide live on in our minds and leave us in a climate of extermination, without consideration of our fellow human beings. We are a society anxious for vengeance and revenge and ready at an instant, to take the law into our own hands."

Tax'a Leon, Chichicastenango, 2003

Ancient Mayan Jade Pendent

SECTION II: MAYAN HISTORY IN GUATEMALA

Rape is a powerful tool used in many wars in which the intent is to create a population suitable for long-term forced labor. The creation of modern Guatemala started with the mixing of Mayan and Spanish blood under violent circumstances. A society whose genetic origins involve rape on a mass scale is more prone to stress. Cultural stress exhibits itself in a variety of forms and can have a ripple effect that institutionalizes mass trauma over the centuries. The K'iche' genocide is not an act of violence that has occurred in isolation, rather it is the latest in the history of conflict between the two cultures that dates back 500 years.

The origins of the genocide directed at the indigenous population by the Ladinos (Guatemalans who no longer identify with the Mayan part of their ancestry) date back to this birth of Guatemala. Contact between two distinct cultures throughout the course of history has often resulted in one trying to dominate the other through war, violence or the threat of violence. The losers are massacred, enslaved or put under economic dominance. The Maya have not been willing participants in the Guatemalan State. Their role has been that of forced labor. Simply put, the Ladinos want to maintain a source of cheap labor and the Maya do not wish to be that source. Racism is used to maintain this unequal system by establishing a value system that ranks Westernization as superior to Mayanization. This stereotype is systemically reinforced in all Guatemalan schools. The tool of racism has maintained the Guatemalan socio-economic system for 500 years. Racism has historically been a very effective economic tool to rationalize slavery and forced labor. Racism and other forms of class separation institutionalize hate and resentment on the part of the oppressed class and self-confidence, superiority and disdain on the part of the ruling class.

Our book is a snapshot (or painting) of the Maya today. The following is a brief history to outline the events that led up to today's Guatemala to help the reader understand how the past has made the present.

Of the estimated 6 million Maya, 5 million reside in Guatemala. The K'iche' represent the largest Mayan cultural linguistic group in Guatemala and are the testifiers and artists of this book. There are at least 21 different groups belonging to the Mayan cultural linguistic family in Guatemala. 1998 census data estimates the Guatemalan population at 11.5 million. If results are typical of the region Tax'a covered when she went house to house as a member of the Guatemalan government census team in 1998, the census numbers of K'iche' people may be an underestimate. Tax'a's neighbors only reported about half the number of people living in their households.

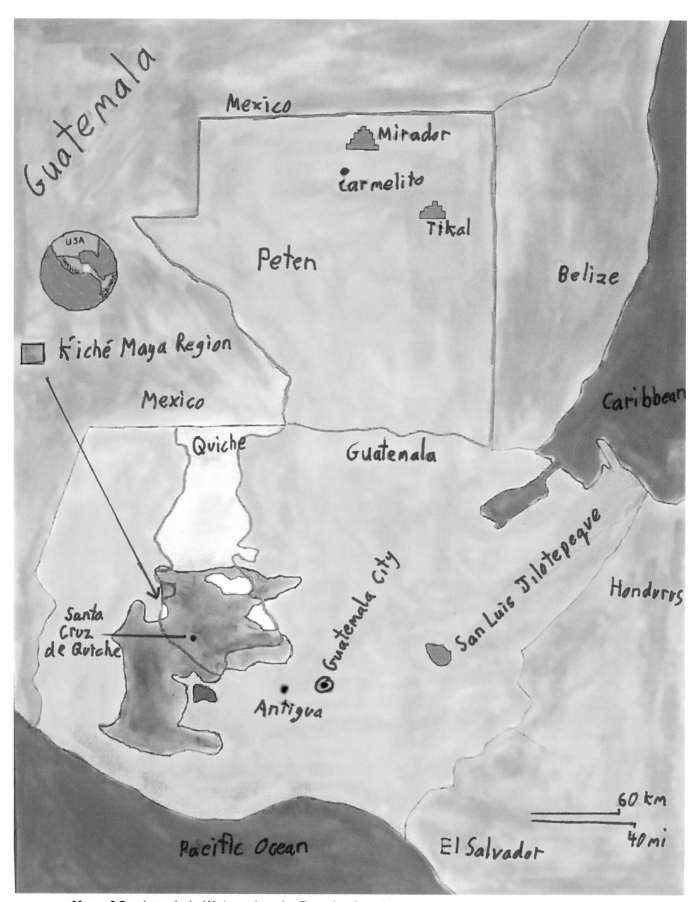

Map of Guatemala in Watercolors by Douglas London

Throughout the five centuries following the Spanish occupation of Guatemala there have been frequent Mayan rebellions followed by repression and violence. The wealthy "Ladino" inheritors of the Spanish legacy still fear a huge revolt from the Maya. This partially explains the violent overreaction to a relatively insignificant guerrilla movement starting in the late 70s that turned into genocide. Let's take a look at the history of Guatemala in chronological order:

2000 BC

The Mayan Long Count calendar dates back 5021 years, year zero being August 11th, 3114 BC. The ritual calendar has 260 days and the solar calendar has 365. Both were in use throughout Mesoamerica including the Mayan regions.

By this time the Maya were building immense stone pyramids, elaborate palaces and public structures and huge cities. The Maya were engaged in making accurate astronomical records, inventing a mathematical system (including the invention of 0), creating complex calendars, sophisticated ritual ballgames and beautiful and intricate jade and ceramic creations. Mayan ruins throughout Guatemala today contain spectacular architectural structures.

Mesoamerica was the birthplace of one of only two verified independently developed languages in the entire history of humanity. These Mayan hieroglyphs are found in public architecture, artwork and in papers that were not destroyed by the Spanish. The other verified original world language is Sumerian, from which English and many other languages are presumed to have evolved. The Mayan languages are still used today.

Bark paper books coated with plaster were still in use when the Spanish arrived in 1524, meaning a literate Mayan population existed up to that time. Remains of bark books have also been found in ancient Mayan tombs. Unfortunately the Spanish burned almost all the books and with it any literate Mayan society. Only books on astronomy and the calendar remained.

900 AD

Most of the great Mayan cities in Mesoamerica were abandoned by AD 900, some five centuries before the coming of the Spanish. (This collapse is discussed later.) Toltec invaders entered the highlands of Guatemala from Mexico. Through their alliance with the Toltecs, the K'iche' established themselves as the dominant Mayan group. The K'iche' were the most

powerful Maya group when the Spanish conquistadors arrived in 1524.

The Colonial Period

At the time of the arrival of the Spanish it is estimated that there were 14 million Mayans living in Central America. The "conquistadors" brought new infectious diseases from Europe which decimated the Maya, leaving an estimated 2 million Maya alive.

Guatemala had no natural resources or riches that could be readily shipped to Spain. The "conquistadors" decided to focus on the human resources available in Guatemala. The Maya were brought from scattered traditional towns into artificial Spanish towns with a Christian church, for religious conversion and to provide a captive work force. Thus, the institution of forced labor became the lot of the entire Maya population. When the indigenous people were not working for the Spanish in their agricultural plantations, they paid taxes on all the labor and agricultural efforts for their own family survival. Taxation became a key source of income for the Spanish.

20th Century Guatemala

From 1944 to 1954, Guatemalan President Arbenz organized the first significant land redistribution and credit system for the poor in Latin America. The land reform affected the US banana grower United Fruit Company. The fruit company, the CIA and US government, elite Guatemalan landholders and the army organized a coup. The threat of a US invasion forced Arbenz to resign in 1954. After the CIA coup, a series of dictators followed, plunging Guatemala into decades of terror and state controlled violence. All told, the Guatemalan government executed over 200,000 of its citizens over the next four decades.

In the late 1970s, a minor Marxist guerrilla movement formed that was centered in the highlands around the Mayan population. The US government gave the Guatemalan army military equipment and specialized training that included the establishment of intelligence practices to prevent the spread of "communism" in Guatemala. The Guatemalan military machine began to much more effectively terrorize, torture and massacre its citizens.

The high watermark of the Guatemalan genocide occurred from 1978 to 1983 under President Lucas Garcia and later President Rios Montt. Hundreds of Mayan villages in K'iche' and the rest of the highlands were razed and on many occasions all their inhabitants were machine gunned and then buried in a mass grave. The vast majority of these "secret cemeteries" in Tax'a's region have not been excavated in spite of pleas from the relatives of the dead. Over a million Maya fled the highlands and became refugees in Mexico.

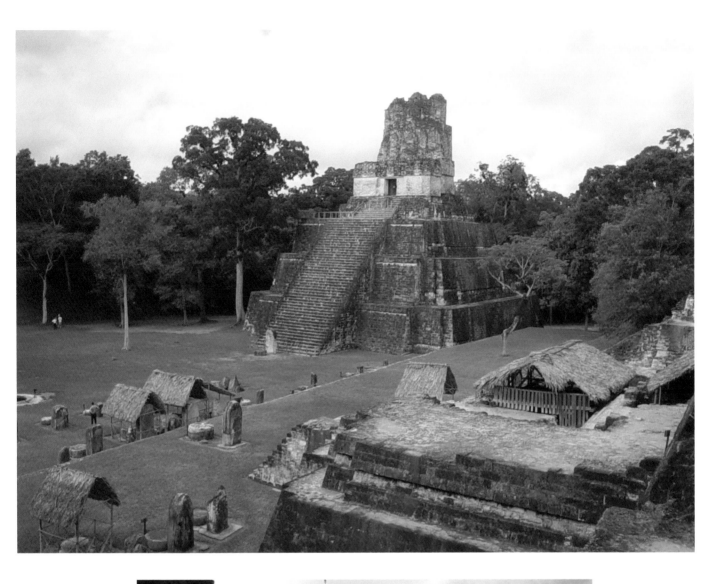

Ancient
Mayan City of
Tikal in
Peten,
Guatemala
(above)

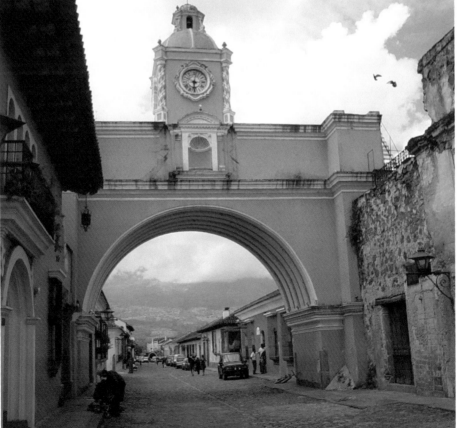

Photos: Douglas
London

Spanish
Colonial City of
Antigua
Guatemala
(below)

Approximately one million people were forced into the Civil Defense Patrols (CDP) to patrol their own towns and report to the military if their neighbors engaged in "suspicious" activity. The Guatemalan military forced the Maya to collaborate in acts of terror against their own neighbors creating bitterness and hate and division in the Guatemalan highland towns and villages up to the present day. The US government continued to support the Guatemalan military during this period. The whole country was traumatized as people disappeared forever off the streets of Guatemala City and other towns and piles of bodies turned up daily. The Guatemalan army is not really an army in the sense that it has never had to stand up to another significant armed force and has mostly focused on killing unarmed men, women and children. It is unclear how the Guatemalan army would fare in a real war with real danger.

A peace accord in 1994 brokered by President Arzu and entry of UN observers into rural areas of the country has helped reduce state-sponsored violence. The government started some new programs including legal representation and more educational opportunities for the Maya and a formal recognition of the Mayan culture as a valid entity.

Guatemala in the 21st Century

A principal author of the genocide, General Rios Montt ran for national election as President in 2003. Although Rios Montt lost the election, he has yet to be prosecuted for any genocide or war crimes and was head of the Guatemalan congress until 2003.

The lack of interest in creating an internal market and a Guatemalan consumer capable of buying a meaningful amount of goods and services is one of the prime reasons poverty remains in Guatemala. To create an internal market the government would need to enforce wage increases.

Drug trafficking to the United States, increased criminal violence and street gangs that control neighborhoods in both urban and rural Guatemala have replaced the political violence of the past. Large numbers of former soldiers have turned to crime.

The United Nations entered Guatemala in January 1997, after the signing of the 1996 peace accords, to oversee a transition to peace. The United Nations presence provided a degree of protection for the Maya. Less than a decade later the United Nations has withdrawn from Guatemala leaving the Maya without protection and still pleading to finish uncovering the massacre sites.

Opposite: "Agua" Volcano rises behind Antigua Guatemala. Photo by Elizabeth London

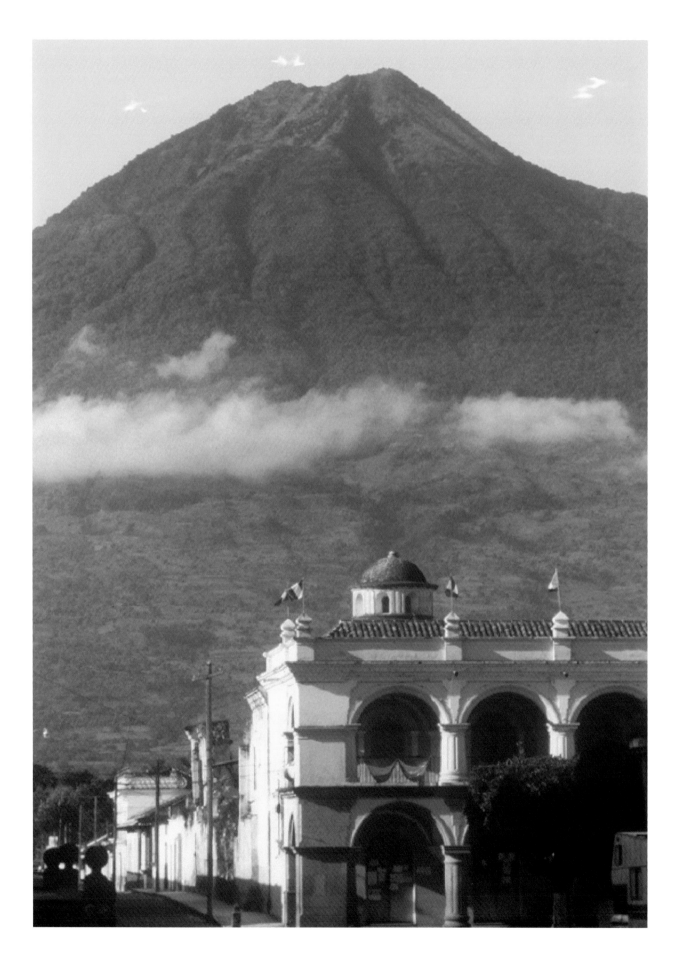

More Maya were killed in Guatemala through state sponsored violence during past decades than in the entire combined Western Hemisphere during the same time period. That includes all the massacres in Argentina, Brazil, Chile, Peru, El Salvador and Nicaragua among others, put together. Why has Guatemala, a tiny nation of only 12 million people had such a large section of its population eliminated? It has a lot to do with Guatemala having the largest intact Native American population in the Americas.

The Maya feel little support from the outside world. Even many of the aid organizations that have been in Guatemala during the genocide and continue their work today unwittingly perpetuate a sense of cultural inferiority, partly because they employ Ladinos in key positions and partly because they promote Western rather than Mayan development. There was such silence in Guatemala on the part of the Maya that it was decades after some of the worst massacres before people outside of Guatemala even became aware genocide had occurred. It was a silent genocide in which at least 200,000 were murdered with hardly a sound reaching the outside world. Only now, when human rights groups and others are beginning to dig up the massive amount of secret cemeteries, is the true scale of the genocide becoming evident. These groups need more international aid.

Tourists have always been carefully protected in Guatemala. The Guatemalan government is improving tourist facilities and welcomes tourists and encourages them to visit the country. This book is not meant to discourage tourism. Guatemala is one of the most beautiful countries in the world and we recommend that tourists visit. There is crime in Guatemala but tourists are as safe in Guatemala as in many other countries in the developing world. (Most governments provide their citizens with current tourist recommendations.) Guatemala is well worthwhile visiting. It is important to work with the Guatemalan government rather than against it to promote change. Your visit to Guatemala helps develop the country and protect the Maya. Like any society there is good and evil. There are many good people in Guatemala who would like to change their country. There have been several recent moderate governments that have improved Guatemala somewhat. Exposing evil and criticizing the perpetrator and doing no more leaves the job half done. It is important to support and protect those who wish to make positive changes in Guatemala as well as stop those who cause evil.

It is the inhabitants rather than the tourists that face danger. Today the Maya face a problem more serious than ever before. The 2000-year-old Mayan culture is in danger of disappearing forever in the next few decades under a wave of violence, racism, poverty, trauma and Westernization. The Maya need international help. This book gives you the Mayan story. It is up to the readers to decide if they want to get personally involved.

Guatemala is burning!

Title: Mi Guatemala Inmortal **Artist: Jose** **Age: 16**

Douglas on top of an overgrown buried Mayan pyramid.

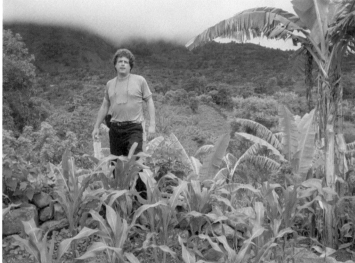

Monkeys in the jungle trees.

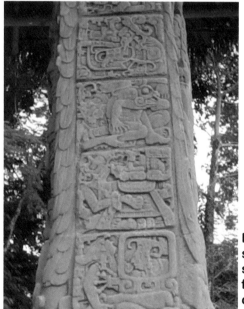

Jaguars still reside in the Peten jungle and are revered by the Maya. This wooden jaguar was carved by Mayan artisans.

Photos on page by Douglas London

Mayan stone carving from Quirigua. These stone "Stela" monuments often tell the stories of long forgotten kings. Many are found in the central plaza of lost Mayan cities throughout Guatemala often buried deep in the jungle.

JOURNEY INTO THE PAST

During the two thousand years of Mayan dominance in Mesoamerica there were numerous collapses that resulted in the abandoning of large cities, only to see other cities appear hundreds of years later. The single most spectacular collapse occurred around BC 100, when the population of the giant Mayan city of El Mirador disappeared. The reign of El Mirador, the largest Mayan city ever built, was from BC 1400 to BC 100, over 1300 years. Within the city are two of the world's largest pyramids El Tigre and Dante. Today El Mirador is located deep in the heart of a remote uninhabited region of the Peten jungle in Guatemala. Mirador dwarfs the more well known, beautifully restored city of Tikal to the south.

DOUGLAS'S TREK TO EL MIRADOR

In 1988 I undertook what turned out to be a rather dangerous odyssey, hiring a local guide, Antonio, and setting out to machete my way through the jungle to find El Mirador. This was before the days when tourists had access to remote areas like Mirador. Mirador was 4 days walk from the nearest outpost of humanity, the tiny village of El Carmelito.

My guide Antonio was a "Chiclero". Chewing gum is called "chicles" in Spanish and originally came from the sap of trees common in the Peten and was extracted like maple syrup. The invention of synthetic chewing gum ended the era of sap gathering in the Peten. During that era, there was a need for Chicleros, who ventured far into the Peten to tap the trees. Chicleros were the only humans familiar with and comfortable surviving in a swelteringly hot and humid jungle, often over 100 degrees Fahrenheit, with virtually no surface water for drinking. The Peten earth consists of not more than an inch or two of soil covering a porous limestone base. Most Peten rivers flow underground and are not easily accessible.

Antonio assured me there was a well two days journey into the route to the ruin. So we took only 3 days worth of water, a heavy load for that climate. Antonio referred to our trail as a Mayan highway. An artificially raised roadway was visible beneath jungle growth off and on during our journey to Mirador. After two and a half days cutting our way through the jungle we arrived at the well. To my dismay it was dry. The days of the Chiclero were over and Antonio had neglected to tell me he hadn't been here for years.

We couldn't survive the two and a half-day trip back with the little water we had. It occurred to me that Mayan cities the size of Mirador must have had some source of water for the enormous population. Antonio told me that Mirador was close, only a day's walk away. So we made the decision to press on, there really weren't any other great options.

As we left the well, I thought the situation couldn't get any worse but I was wrong. It rained. The rain was relatively brief and immediately soaked into the ground. We continued through the undergrowth, and as I brushed against leaves and vines, I started to collect passengers. The rain had brought the ticks out. By the end of the day I had 40-50 ticks on me, happily sucking my blood. I was unable to remove these insects, so they sucked out my blood until they had their fill then dropped off only to be replaced by others for the rest of the time I spent in the jungle. Having ticks all over his body didn't seem to bother Antonio at all.

We reached the ruins the next day with no water. The pyramids were mountains of jungle growth. We ran into what turned out to be the abandoned National Geographic Magazine camp in the center of the ruins. From the swath of jungle cut down nearby it was obvious National Geographic had used helicopters rather than a machete entry, eminently more practical. We began to scour the city for water, which we found a few hours later near the camp. The grand reservoir I had been dreaming about turned out to be some mud with a film of liquid green-brown slime. We spent hours scooping the moisture off the slime and putting it into bottles and drank slime water for the next five days. For fresh food Antonio used his jungle skills. In the morning he put spikes on his boots and sticking them into tree trunks would shinny a hundred feet in the air to the jungle canopy and return with a bird egg for breakfast.

We spent three days exploring Mirador, an enormous, deserted, lost and jungle covered city in the middle of nowhere. The ghosts of the Mayas seemed to be all around us. We macheted our way up and around many buildings including the La Dante pyramid, considered by many to be the world largest pyramid at over 237 feet high. From La Dante we could see the green tops of the jungle trees stretch away to the horizon on all sides.

We slept in the open jungle in the middle of an empty Mayan city in a plaza crowded only by memories. Our hammocks were slung between two trees. We taped scotch tape, sticky side up, around the hammock ropes to impede the ant's desire to crawl all over us. On those nights in Mirador I had only jungle noises to occupy my mind. I imagined what Mirador might have been like as a thriving metropolis. Why had all the people vanished? It occurred to me how vulnerable the city's populations would have been to a severe drought. If drought was a principal factor in the final blow that lead to the complete disappearance of the population of El Mirador in BC 100, we came close to sharing their fate in AD 1988.

About nine hundred years after Mirador's collapse and 800 years before the arrival of the Spanish, the entire Mayan civilization in Mesoamerica went into an enormous collapse.

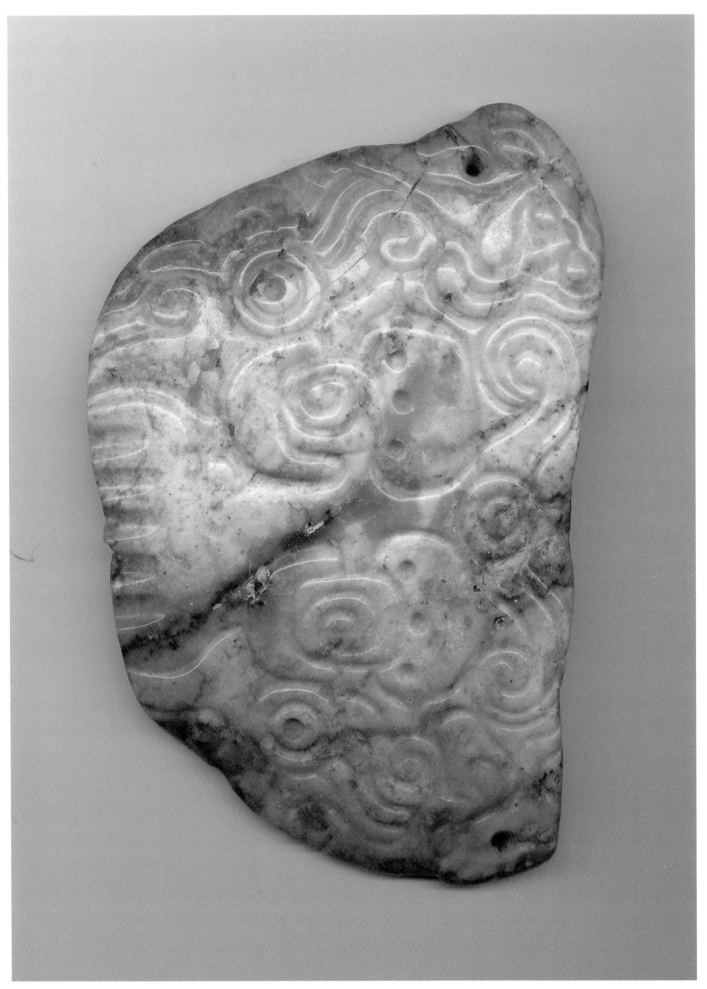

Photo: Douglas London

Ancient Mayan Jade Plaque

The Peten region of Guatemala lost more than 99% of its Mayan population in the course of the collapse that ended the Mayan city-state system forever. The population in the Peten is estimated as having been as high as 14,000,000 people. The massive Mayan populations of the past far exceeded the present day Guatemalan population and overused the region's natural resources. Severe drought, a vulnerable agricultural system and over use of natural resources appear to be the leading causes for the complete disappearance of entire Mayan city-states and millions of people populating them in the space of a few years. When the Spanish arrived they found approximately 30,000 people in the region. Outside of the Peten, the rest of the Mesoamerican Maya region also lost between 90-99% of its population after AD 800.

Droughts may be cyclical in nature and recent literature suggests they occur about every 208 years due to small variations in the sun's radiation. The occurrence of these droughts coincides with many Mayan city-state collapses during the 2000-year reign of the Maya in Mesoamerica. There is evidence that the collapse of various ancient Mayan city-states coincided in time with the collapse of other ancient civilizations in different parts of the world. These periods of intense drought may be global in nature. According to experts, the worst drought in 7,000 years began around AD 760 and peaked around AD 800 with smaller peaks in AD 820, AD 860 and AD 910. This coincides with the final collapse of all the Mayan city-states in AD 800-900.

Guatemala is on the fault line that divides North and South America. Guatemala is a land of 36 tremendous and often active volcanos, all in a territory smaller than the US State of Tennessee. There have been numerous eruptions over the centuries. Earthquakes are also frequent in Guatemala. The earthquake of 1976 took over 10,000 Guatemalan lives and ended talk of invading neighboring Belize.

The Maya were great astronomers and paid attention to the summer and winter solstices, stars, planets and other celestial cycles. Perhaps they wanted to understand the celestial cycles that caused drought and other natural phenomena that are still so destructive to their world. Hieroglyphs on ancient carvings reveal Mayan kings made promises to their population to intercede with nature to avoid droughts and other natural tragedies that plagued the Maya. Mayan tradition and culture today still focuses on interpreting the vagaries of nature and emphasizes the importance of great respect for the natural world. The remaining Maya today are vigilant in maintaining a good relationship with nature. Today, humanity is again rapidly destroying the world's natural resources. We should all pay attention to the Maya's example or risk sharing the same fate as the great Mayan cities.

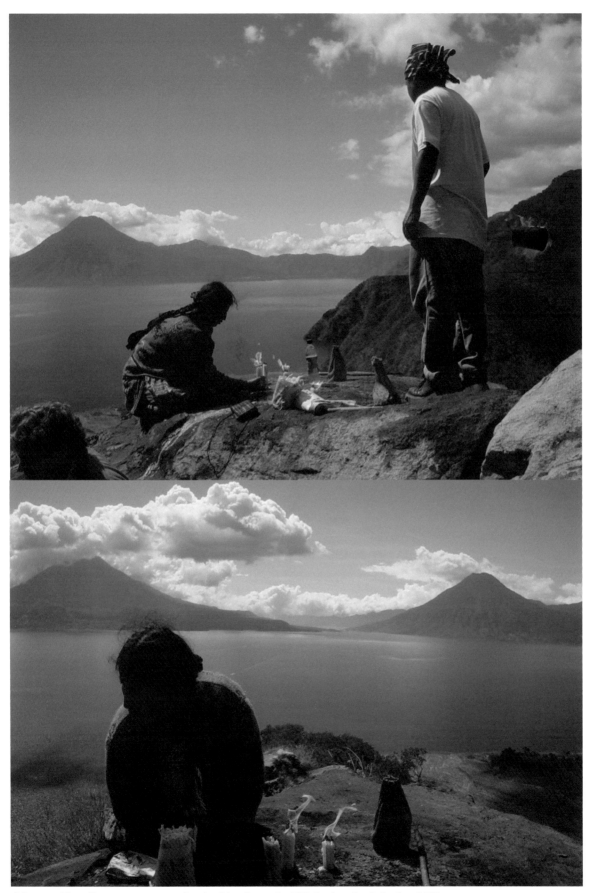

Mayan Fire Ceremony conducted by female K'iche' priest, Lake Atitlan. Photos: D. London

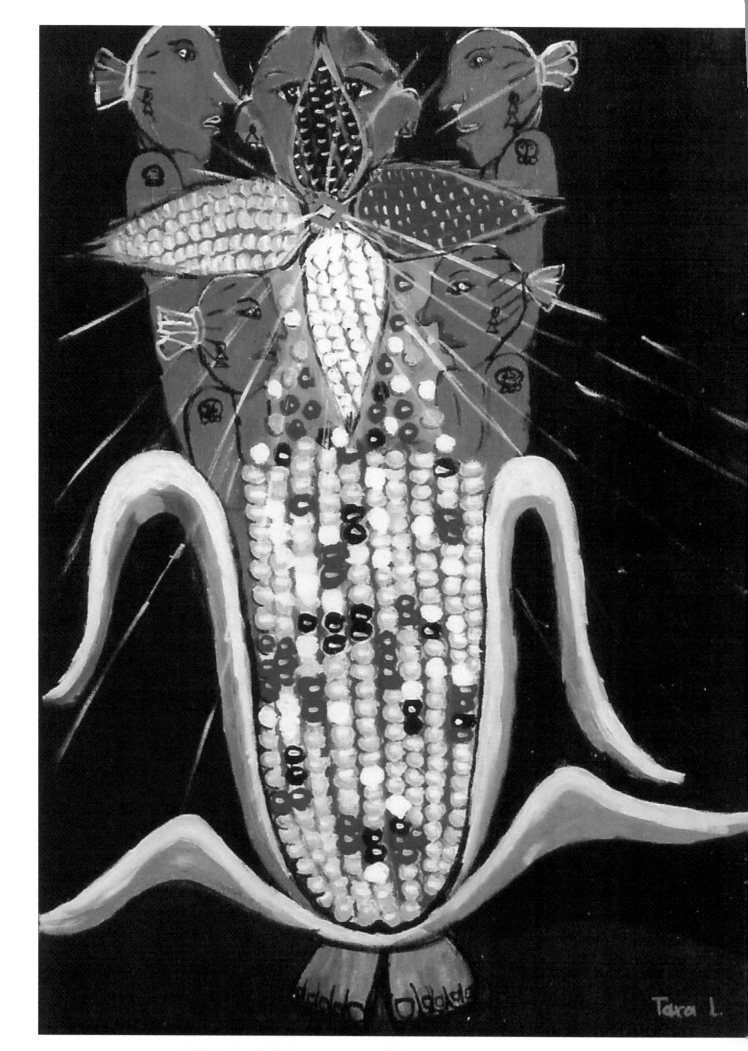

CORN, AGRICULTURE AND WAR

In a post-hunter gatherer society, agriculture is the foundation of human nutrition and consequently societal health. Nutrition and agriculture played a significant role in shaping Mayan history. A vulnerability in the Mayan agricultural and nutritional system contributed to the collapse of the Mayan city states of the past, played a role in their defeat by Spanish invaders and continues to be a debility for the modern Maya.

All societies have vulnerabilities. The Maya's greatest strength and at the same time greatest vulnerability was corn.

Corn originated in the Americas. Corn was the staple of the Maya, Inca and Aztec civilizations in the Americas. The existence of the family of corn plants pre-dates indigenous human arrival in the Americas. Corn was introduced to Europe from the Americas by returning Spanish conquistadors. Corn is now widely distributed in Europe, Africa and Asia and has become the staple crop in many developing countries. Corn is still the principal food of the Maya today. Feliciano Gomez, a Pokomam Mayan elder explained to me:

"In our Mayan culture there are only two categories of food, real food and extra accompaniments not critical to spiritual and bodily survival. Real food equals corn and only corn. All other foods are accompaniments. If you have not eaten corn no matter how much meat, beans or vegetables you have consumed you are starving."

Many other Mayan leaders have expressed this corn-centered concept to us over the years. Corn was accepted by the ancient Maya as the only real food. The ancient Maya were dependent on this single food staple for survival and had to plan their religion, daily activities, architecture, wars, politics, jobs and economy around that food. Success or failure, life or death, corn was the deciding factor. Corn dictated how the Maya time and energy were spent. A society that relies on one staple crop is extremely vulnerable to drought and crop diseases and has a nutritional tight rope to walk to avoid rapid starvation or severe malnutrition of the entire population.

A society's agricultural and thus nutritional base plays a critical role in its history and can be the decisive factor in conflict when cultures collide. Corn affected the Maya's ability to wage war successfully. In 1848 the Maya in Mexico revolted against their Ladino overlords. The Maya had virtually won the war yet they were forced to break off when victory seemed certain because they had to return to their fields to harvest their corn. Ultimately, the Maya's dependence on corn led to their defeat.

Opposite: "Hombres de Maiz" by Tax'a Leon in acrylic paint.

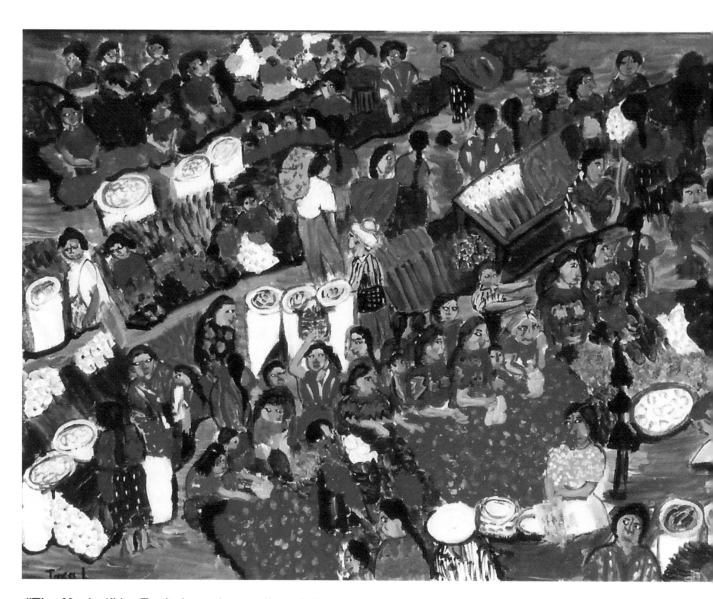

"The Market" by Tax'a Leon in acrylic paint

Maya dependency on corn prevented them from mobilizing in large numbers for widespread or long distance warfare. Corn grain is not a compact or light form of nutrition. Corn dough spoils in a few days. Corn tortillas, tamales and atole drinks represent the principal forms in which corn is eaten by the modern day Maya. All of these foods come from a base of ground corn dough. A considerable amount of corn needs to be carried by the army to allow a soldier to fight for prolonged periods of time. The amount of corn a soldier needs to fight, for any length of time, away from their fields is more than a soldier can carry. The Maya lacked an effective form of transport to carry large stocks of food. Draft animals were not available. Horses were brought over by the Europeans and llama were only present in South America. The wheel, while invented by the Maya, appears to have never been used for transport. Archaeologists have found ancient Mayan toys equipped with wheels but no evidence of the wheel use in transporting heavy objects. A porter bringing corn to the troops in battle would use up all the corn he could carry just to transport himself. A small group of Maya soldiers might be able to live off the land by hunting and gathering food. With a large army this is not feasible.

Archaeological evidence paints the ancient Maya as a group of sophisticated city-states that were often at war with each other. It is remarkable that in 2000 years of conflict between city-states a Mayan empire never developed. In ancient times corn also affected the Maya's success in war. One city-state was never able to become dominant because the Maya could not fight very far from their cornfields. The ancient Aztecs and Incas developed large empires in Mexico and Peru respectively. Both these civilizations had access to multiple staple foods or diverse agricultural techniques. The Maya never had access to other staple crops simply because no other suitable foods grew in the region of Mesoamerica.

Agricultural Modernization and the Maya

Today, once again, agriculture may play a significant role in the Mayan culture's vulnerability. There are two main destructive factors at play today and both come to the Maya from the West. One vulnerability is nutritionally based and the other comes in the form of powerful agricultural chemical toxins.

Tax'a's family and other Maya use powerful deadly toxins in the form of herbicides, pesticides and fertilizers to protect their corn harvest since crops are as vulnerable to plague, drought and natural disaster as they were in the days of the ancient Maya.

Ingestion of these agricultural chemicals causes disability, disease and early death. This poisoning is frequently a slow cumulative process, making it difficult for a farmer to recognize the source of the deterioration in their mental and physical health. Compounding the danger is the lack of understanding of appropriate safety precautions needed in handling these chemicals.

These modern agricultural chemicals play an underrated but very destructive role in the health and well-being of the Maya today. Drinking Gramaxone, a universally used agricultural chemical in Guatemala, is a common method of suicide among the Maya. Our psychiatric clinic in Guatemala has frequently noted Gramaxone's use in Mayan suicide. The rate of suicide among the Mayan population is much higher than statistics indicate because it is almost never reported.

Chemical companies seeking profits continue to produce these agricultural chemicals for the developing world long after there is conclusive scientific evidence these chemicals are deadly and inappropriate for human use. Most of these dangerous chemicals have long been banned in Western countries.

Beyond toxic chemicals, the lure of modernization has led to the importation of other inappropriate agricultural and food system practices into a malnourished and nutritionally vulnerable, modern Mayan world.

Like the infectious diseases brought by the original Spanish invaders, the West once again is bringing destruction, this time under the guise of development and modernization. An agricultural system made up of toxic chemical cast-offs from the Western agricultural chemical companies, combined with inappropriate new foods and preparation techniques (described below) have hit on the vulnerable spot in Maya society once again, corn.

The Maya's reliance on a staple food means even a minor nutritional modification of corn can have profound effects. New agricultural techniques cause nutritional modification of food content. Wealthier nations have hedged their food portfolio by having access to a wider variety of foods from a wider variety of sources. Thus, the West is more protected from vulnerabilities in their own agricultural system. Diseases in which Western agricultural and food processing technology plays a significant role have entered the Mayan world. Diabetes, heart disease, hypertension, stroke, arthritis and certain types of brain disease once unknown to the Maya are becoming increasingly common.

The Western custom of frying foods with hydrogenated vegetable oils is replacing traditional Mayan firewood cooking practices such as boiling and grilling. Boiling soups and stews preserve nutrients that leech out of food into the water as it is cooked because the water is consumed. High temperature frying using vegetable oils degrades the nutritional content of food.

Most vegetable oils have an excess of omega-6 fatty acids. Corn and other grains also contain large quantities of omega-6s and virtually no omega-3 fatty acids. Omega-3 fatty acids are the essential nutritional counterbalance to excess omega-6s. Lack of dietary omega-3s is implicated in heart disease, arthritis, diabetes, certain mental illness and other manmade chronic illnesses previously rare in humans. A corn based staple diet already has an excess of omega-6 fatty acids. Adding Western cooking oils loaded with omega-6 fatty acids to a corn based diet pushes the Maya into potential fatty acid misbalance and vulnerability to chronic diseases previously not a factor in their health.

Another integral component of modern agricultural techniques, processed food, has rapidly entered the developing world. Nonfoods such as chips and soda are replacing the consumption of recently harvested, locally produced nutritious foods. These Western processed foods use over 3000 chemical additives in the form of artificial colors, flavors, textures and preservatives. These food additives do not have nutritional value and there has been little research into their long-term harmful effects in humans.

Basing an entire civilization on one food is perilous. The Maya dependency on corn played a role in the collapse of a very successful and advanced city-state society. Corn dependency limited the ability of the 17th century Maya to defend themselves against the Spanish invaders. Corn dependency opens today's Maya to further destruction from agricultural food system techniques imported from the West that are inappropriate to their culture.

All civilizations have their points of extreme vulnerability. Oftentimes this liability comes in the guise of a culture's point of greatest strength. What is the greatest vulnerability of the culture you, the reader, belong to? What you perceive as your society's principal assets and points of greatest strength may also contain the seeds of destruction. Look carefully.

K'iche' Woman **Photo (1986): Douglas London**

SECTION III: WHAT MAKES A MAYA MAYAN?

WHAT MAKES A MAYA MAYAN?

We hope this book gives some insight into what it is like to perceive the world as a Maya does. In this book we take a glimpse into the culture of the K'iche' Maya, a way of life that is beautiful and sadly disappearing in a sea of violence and Westernization. Having a world where everything is westernized gives us no reference point and no way to learn about ourselves. Cultural diversity is not a danger to the West. Loosing the 2000-year-old Mayan culture is a tragedy. Each tragedy and genocide pushes humanity one step closer to complete destruction by our own worst enemy, the one we see in the mirror every day. If we see ourselves through another culture's eyes, our true strengths and weaknesses are revealed. We may not always like what we see. But if Western civilization destroys all cultural mirrors, "Westeners" will lose the ability to see their most formidable enemy, themselves. Then there is no stopping that enemy from destroying us.

Many Guatemalans who reside in the US like to call themselves Maya, perhaps because indigenous cultures are romanticized in the US. Few of these persons would be considered Maya in Guatemala. Guatemalans that do not speak a Mayan language fluently have significantly distanced themselves from the Mayan culture and in Guatemala are called "Ladino". A Ladino is a Guatemalan person that does not practice Mayan customs even if they have 100% Mayan biological ancestry. The term Ladino is somewhat different from Mestizo (mixed indigenous and European ancestry) or Latino (Latin American).

The Maya are close to nature, community respect is the basis of the legal system, the community is interdependent and the lifestyle is communal. The Ladino is somewhat further removed from nature, division of property is the basis of the legal system, independence is more pronounced and the game of life is the achievement of individual success.

What makes a Maya Mayan, is not language, dress or even racial characteristics (as many Ladinos are identical physically to their Mayan counterparts).

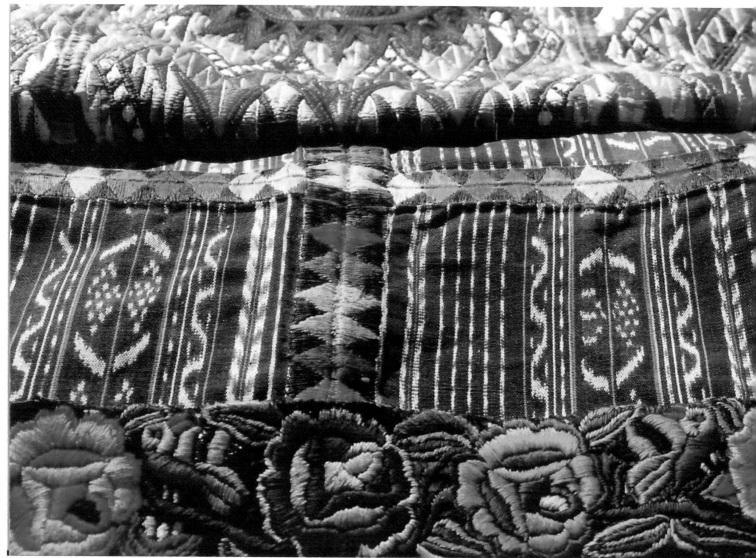

K'iche' corte (skirt), faja (belt) and guipil (women's woven blouse)

Photo: Douglas Lond

What makes a Maya Mayan is more a question of which end of the cultural spectrum the particular person and previous generations of their family have chosen or been forced to associate themselves with; Mayan or Western. The following come from conversations and conflicts we have had during our marriage, "Mayan" being Tax'a and "Western" being Douglas. Our disagreements illustrate cultural conflict and are not intended to be generalized to all Maya or all Westerners.

MAYAN: Individual initiative discouraged as it disrupts harmony. Group efforts to achieve success admired.
WESTERN: Destruction of group efforts in the pursuit of individual success is not uncommon. Individual ambition is socially accepted and admired and is often called "freedom".

MAYAN: Marriage is the union of families.
WESTERN: Marriage is the union of individuals.

MAYAN: Marriage is the responsibility of the community.
WESTERN: Marriage is the responsibility of the individuals.

MAYAN: Blame is on nature.
WESTERN: Blame is on the individual.

MAYAN: We are part of the past.
WESTERN: We need to improve in the future

MAYAN: The dead are always with us when we need help and remind us of our immortality.
WESTERN: The dead remind us of our individual mortality.

MAYAN: Things need to be taken in a long term context to be understood.
WESTERN: Problems need to be divided into small enough pieces so that we can understand them.

MAYAN: I create my importance by adding to the community.
WESTERN: I create my importance by climbing to the top of a hierarchy. Money, position and power are milestones.

MAYAN: Reliance on tradition, difficulty adapting to change.
WESTERN: Adapt to conditions by innovation.

MAYAN: Ready to take action when tradition is threatened.
WESTERN: Ready to take action when my individual property is in question or my government or religion requires it.

MAYAN:	Food is part of tradition. Food ties the body and mind to nature.
WESTERN:	Mental distance from nature, the source of our food. Food is a means and source of enjoying life for the individual.
MAYAN:	Violent emotions and behavior are controlled by tradition, it is shameful to step outside of tradition.
WESTERN:	Violent emotions and behavior are controlled by written laws.
MAYAN:	A person's emotional support comes from personal advice, family structure, and belonging. Loneliness is very uncommon among the Maya.
WESTERN:	A person's emotional support comes from helping individuals to help themselves and incentives to succeed as individuals. Loneliness is a very common problem for individuals in Western societies.
MAYAN:	Emotional well being: feeling of confidence in culture and tradition.
WESTERN:	Emotion well being: self-confidence.
MAYAN:	The worst kind of shame: shame of failure to function as part of society.
WESTERN:	The worst kind of shame: shame of individual failing.
MAYAN:	Dietary problems cause malnutrition.
WESTERN:	Dietary problems cause chronic diseases.

The two extreme endpoints on the Mayan to Western spectrum represent completely different ways of interpreting life. These foundations of perception of the world around us are so basic that they are taken for granted as being universal by Westerners. As we hope the following chapters will demonstrate, the things we hold to be immutable, unchangeable facts are actually opinions based on cultural upbringing. Extremes are instructive, so we will contrast and compare some traditional Mayan and traditional Western cultural tendencies in the following chapters to gain insight into both cultures. The reader needs to bear in mind that the cultural reality in Guatemala and the West is blurred and ambiguous and the examples given are a reference point, not necessarily a universal norm.

Opposite: K'iche' Woven Mantel

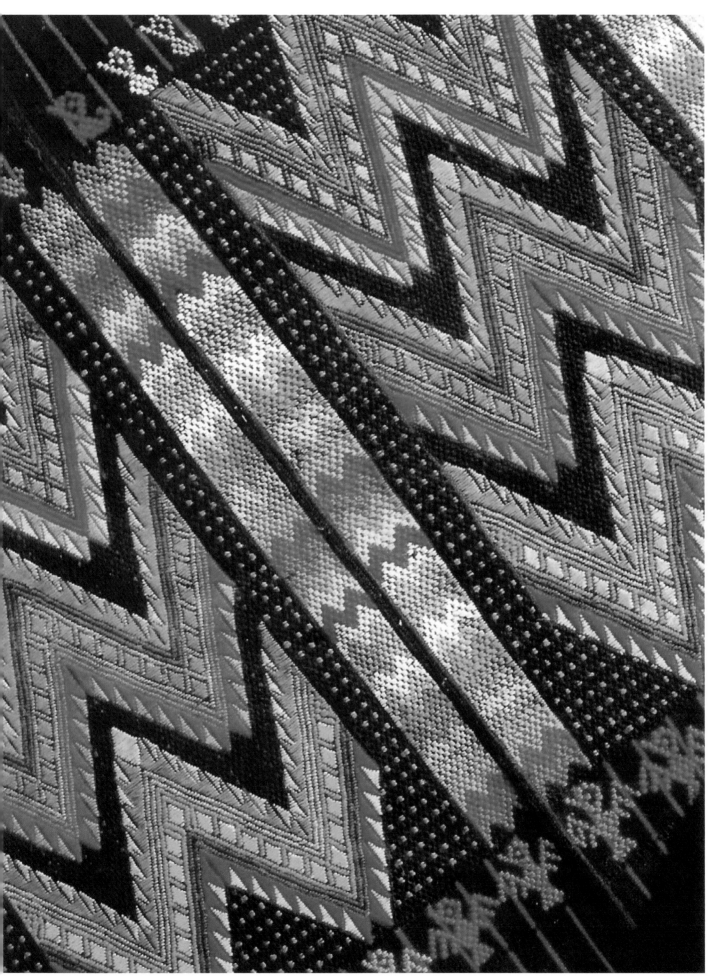

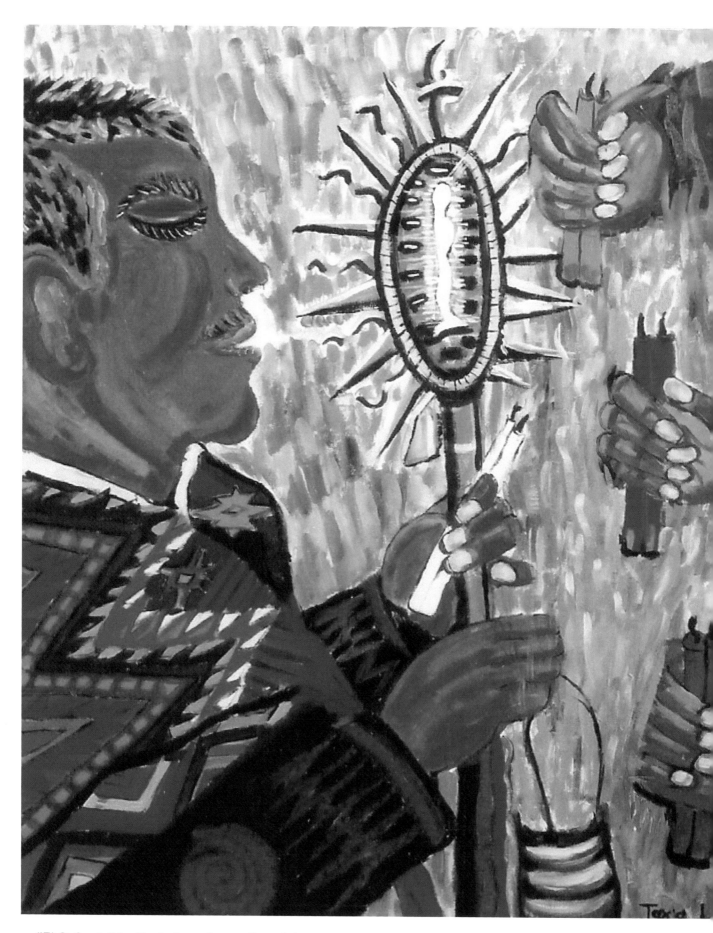

"El Cofrade" by Tax'a Leon in acrylic paint.

THE ROLE OF THE DEAD

For the K'iche' achieving success in life necessitates absorbing enough momentum from the past to propel them through the present. This momentum comes from the Mayan family and community but not just from those presently living. Those who have died and gone to the other world have an active role in the family. The dead are present in all aspects of K'iche' life.

Many traditional cultural activities still take place around a K'iche' funeral in 2006. The dead person's tools, jewelry, implements and objects that served the person best in this life are buried with the deceased to make them comfortable and successful in the next life. Unburied personal objects are believed to be a source of problems for living relatives. In the same vein, ancient Mayan tombs excavated by archaeologists contain extremely valuable objects such as jade carvings that were not kept by ancient Mayan relatives. The dead do not haunt the Maya like a stereotypical Western movie or TV cartoon. Rather, the dead provide protection, wisdom and energy for the living. For the K'iche' remembering and respecting the dead is a way to increase your value as a human being and member of the community.

Modern Halloween in the United States coincides with the Day of the Dead in Guatemala, both start mid-night October 31st. On the Day of the Dead in Guatemala, families take a picnic out to the cemetery where their family members are buried. It is a day to remember their relatives who are no longer with them. Kites, seen as connection to the next world, are flown in the cemeteries. The picnic is not just for the living, as the dead are believed to be able to inhale the smells.

In the United States, Halloween as with most traditions, has become a way to make money. A day of respect for the dead has become a costume party for children and adults. The real dead in the USA lie forgotten in public cemeteries surrounded by silent neighbors they most likely have never spoken to while alive.

The Mayan dead are considered an asset to the family and prior to the Spanish occupation were traditionally buried near the house as part of the family life force.

With the support of the Evangelic church she attended, Juana, a Pokomam Maya Douglas has known for 18 years, recently renounced her indigenous ancestry. Juana put it like this *"Why should I care about dead Maya? They have no power to help me with my life"*.

A dwindling number of Mayan towns still have Cofradias. The institution of the Cofradia is a combination of Catholic and Mayan traditions. The Cofradia are a group of senior Mayan Catholic leaders who work with the Catholic church to maintain traditions that have their origins in the European colonization of Guatemala dating back five hundred years. The Cofradias have a religious and leadership role in the community. The most visible Cofradia activity for Westerners is the religious processions that carry the town saints through the streets on special ceremonial days. The traditions of the Cofradia are rich and varied but beyond the scope of this book. The Cofradia's ceremonies use many techniques of indigenous origin in a Catholic context including incense, drums, corn drinks in gourd shells and pine needles on the floor to add to the beauty of the ceremony. More traditional Mayan ceremonies used the scent of pine needles and incense to summon ancestors. These additions make Catholic practices more accessible to the Mayan culture. The modern Catholic Church is the principal protector of indigenous human rights in Guatemala and plays an active and important role in the preservation of Mayan culture.

Outside of the Cofradia more traditional Mayan religion and ceremonies still exist. Tourists rarely see them because they are conducted in secrecy to prevent persecution from the Guatemalan government. The Guatemalan government has historically been uncomfortable with unsupervised Maya group meetings. Not only Mayan religious ceremonies but even government K'iche' health promotors that organized groups for health education have been routinely killed for "subversive activities" by the Guatemalan military.

Ceremonies are conducted in areas where there is a nearby portal to Mayan ancestors. Often these places are near the tomb of an ancient Mayan king or person of importance. Many of these burial sites are in places high up with a view of the surrounding countryside on three sides. In ceremonies, Mayan priests frequently refer to "the Mayan world" which encompasses all Mayans throughout history. Like the bible and other religious books, Mayan historical figures probably went back thousands of years in history. The Maya were a literate culture. Upon their arrival, the Spanish burned the Mayan books destroying their literate connection to the past.

Ceremonies of pardon, petition and thanksgiving are conducted by an "Aj Q'iij" the name used for a Mayan priest who is also called a spiritual guide. Ceremonies are designed to coincide with special days indicated by the 260 day Mayan spiritual calendar. According to the Mayan calendar, the day, month and year you were born on is your "nawal" (birth sign) which has great significance and predictive power as to what your role in the Mayan community will be. Your nawal dictates the origin of the energy received during a Mayan ceremony.

Volcanoes of Peace" by Tax'a Leon in acrylic paint.

One of the principal focuses of Mayan ceremonies is communication with those that have passed into the next world. The Aj Q'iij (Mayan priest) who conducts the ceremony is viewed as an intermediary between the living and the dead. The time of apprenticeship and training for Mayan priests lasts between 3-6 years. Training is conducted under the guidance of a master priest mentor. Graduation of a Mayan priest is a major community celebration with special ceremonies and dances such as the "dance with a rooster".

INTERVIEW WITH A MAYAN PRIEST

We've had the honor of participating in numerous ceremonies with Don Pedro and he has helped us better understand key aspects of Mayan life. Don Pedro conducted our Mayan wedding ceremony, which lasted four hours, short by Mayan standards. We had our fingers tied together the entire time. It was a moving ceremony that we will always remember. Don Pedro had these words to say about his early training to become a Mayan priest:

"I was born under the nawal Imox. This is a sign of a Mayan priest. At age 7 my parents took me to the local Aj Q'iij. This Mayan priest told my parents that I had a mission. The Aj Q'iij agreed to train me.

My mentor assigned me to a village elder. So as a seven year-old I would report at six in the morning to the house of the village elder to memorize what this man had dreamed about the night before. After memorizing the dreams, I would have to run to my mentor and recount them in detail. This Aj Q'iij would then explain the meaning of the dreams to me.

One day on the way to my mentor, a group of dogs attacked and bit me many times. I was so frightened that I forgot the dreams I had so carefully memorized. I cried all the way to my Aj Q'iij's house. When my mentor asked me what dreams I brought to him today I told him I had been attacked by wild dogs and forgotten the dreams of the village elder. My mentor said that I would have to be disciplined and receive ritual punishment, Xicay, for neglecting my duty. I was frightened and ashamed. On the day when I was to receive my public punishment this Mayan priest relented and said he would forgive me this one time since I was seven years old and had been attacked by dogs. My mentor said I must never again forget another dream. After that, I never forgot a dream or its interpretation and importance for the rest of my life.

After working two years with my mentor on the interpretation of dreams I began my training on how to conduct a ceremonial fire and interpreting the flames."

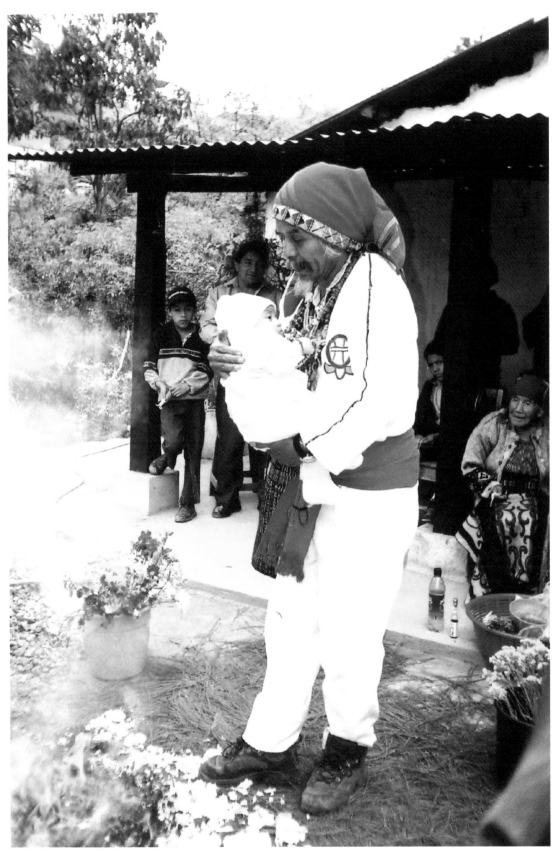

Don Pedro, Mayan Priest

"This training was followed by my study of the reading of the Tz'ite (symbolic 260 sacred red beans). Study of the Tz'ite is developing wisdom to counsel

My training has been followed by over 60 years service as a Mayan priest to the indigenous communities in the highlands of Guatemala. I have no church or building because my church is nature itself. I use a drum and chanting to establish rhythm and harmony with my surroundings. In my house, I have an ancient Mayan stone carved into the form of a personage that was given to me by my mentor when I was seven years old, 64 years ago. I light a candle and pray everyday on that stone. The ancient Maya culture still survives in the world of today."

Testimony: Don Pedro
Occupation and Mission: Tzituil Mayan Priest
Age: 71

Whenever we have seen him, Pedro is carrying a ceremonial "Vara'", which resembles a carved wooden walking stick and a Tz'ite bag. In Tax'a's rendition of an ancient painting of a Mexican Mayan priest you can see the "Vara'" pinning down a serpent. The Mayan priest in the painting probably has a nawal called "Tzikin" (condor, eagle or quetzal). Nawals of ancient Mayans are typically exhibited as a mask or headdress or some other covering of the body, such as the feathers in this painting. Most ancient Mayan art whether painted, molded in clay or carved in stone depicts the nawal of the personage. Many smaller ancient Mayan jade pieces represent just the nawal.

Upon birth, a nawal is assigned to the child by the Aj Q'iij". Nawals are decided by Cholq'ij (birth date). Nawals come from dates on the 260-day Mayan religious calendar. 260 days marks the average length of a human pregnancy. Your nawal determines certain personal characteristics and suitability for certain roles in society. In Tax'a's family, chores are sometimes assigned based on skills designated by their nawal.

Mayan religion has twenty nawals. A person's nawal provides their personal connection to the Mayan world of the past. Nawals are a passage or continuum of energy and life force in the Mayan world. The work that dead ancestors, bearing a certain nawal, could not finish becomes the responsibility of those Maya presently alive, living under the same nawal. A person's contact with ancestors in a Mayan ceremony is directed at ancestors possessing the same nawals rather than biologically related ancestors.

"Mayan Priest Pinning a Snake with a Vara". Rendition of part of a Mexican Mayan mural by Tax'a Leon.

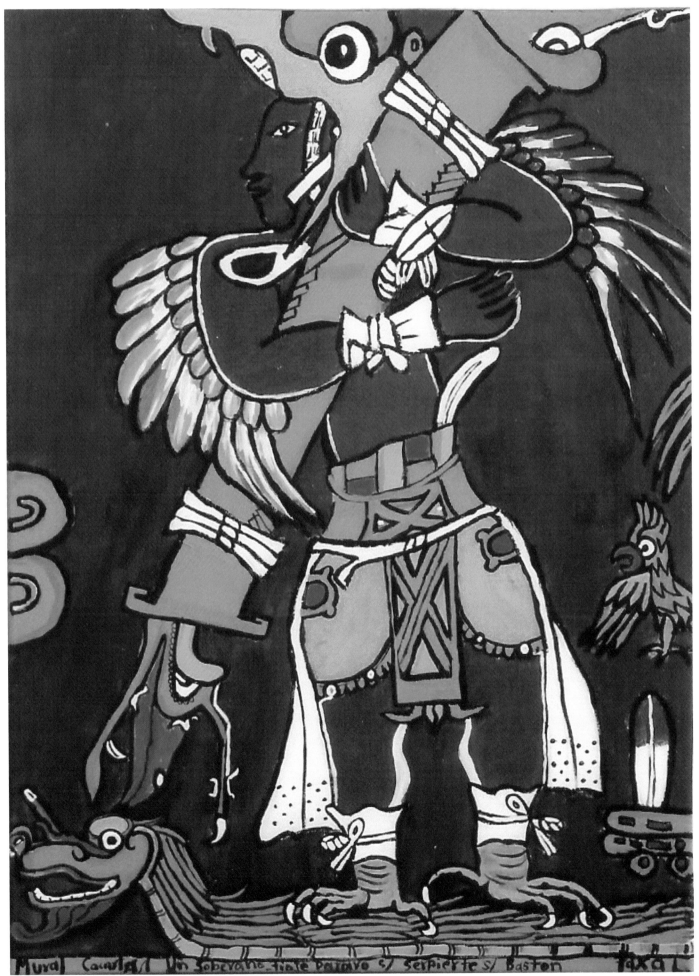

Mural Cuarto/ Un Soberano trate Pajaro s/ Serpierte s/ Baston Paxal

During a ceremonial fire the Mayan priest summons the dead to be with the living. In the flames of the fire the community of both the living and the dead summoned unite their energy to jointly solve the particular problems of the moment. It is believed that the energy from those who lived in the past is stronger than the energy from those living in the present. Thus, the K'iche' are always looking back to the past for their major source of energy, strength and wisdom to assist them in their daily life. The ceremony of fire is the key focal point in the life of the K'iche', providing the transfer of energy between those ancestors of the past to those living in the present.

Mayan fire ceremonies begin with paying respect to nawal ancestors and dead family members. The participants circle around the fire and join hands for collective energy. There are four geographic "cardinal" points to physically orient the location of events during the ceremony often demarcated by ancient Mayan stone carvings.

The fire is carefully designed in a circle using ingredients such as candles, sugar, lemons, eggs, flowers, round "copal" briquettes, special bundles of herbs, chocolate (a Mayan contribution to the world) and other standard ingredients. Lemons and eggs explode periodically throughout the ceremony.

During the ceremony ancestors appear in the flames of the fire, a visual demonstration they are still with the family. What almost appear to be human figures and faces as well as animals materialize in the flames. The specialized traditional ingredients used in the ceremonial fire are designed to create these unusual flames. No firewood is used in ceremonial fires.

Near the beginning of the fire ceremony, Pixab (respect) is paid to the Ajaw (creator) as well as Rajaw Ulew (nature), Pa Choch (the family), Tat (father) and Chuch (mother), Ajil Tz'aqat (the community), K'ulb'at (neighbor) Nimaj Tak Winaq' (the elders) and Ni Malaj Q'atab'al Tzij' (authority). Incense and smoke are believed to provide a mode of transport for ancestors to enter the fire and assure their active presence and participation during the ceremony.

Each participant receives individual attention from the Aj Q'iij and their personal needs, such as curing an illness or resolving a conflict, are addressed. Alcohol is sprayed onto the participants from the mouth of the priest. Candles of many colors, puru (tobacco cigars), cuxa (homemade alcoholic spirits), herbs and other traditional objects are brushed along the body of the participants and thrown into the fire to rid the person of problems and disease.

The Mayan ceremonies help us stay in contact with our grandfathers, spiritual ceremonies bring us advice, the four cardinal points are found in ceremonial places, temples where great Maya rest, near where we live.

Title:	**Ceremony**
Artist:	**Juana**
Age:	**13**
Medium:	**Oil Crayons**

The participants throw additional candles of various colors onto the fire at certain times during the ceremony. Candle colors have distinct meanings and different colors are used at particular times during the ceremony. The ceremonial fire lasts many hours. The priest determines ceremony length based on the type, quantity and positioning of the ingredients used to burn in the fire. When the fire dies the ceremony is over.

The Mayan sometimes sacrifice chickens in these fire ceremonies. Westerners are often taken aback by ceremonial sacrifice. Sacrifice is a common theme in most religions. Christians use the Cross, a symbol of torture and death to remember that Jesus sacrificed his life so others may live. It puts things in perspective if one remembers that every bite of food any human eats is a bite into a formerly living animal or plant. That living animal or plant, with or without ritual, was sacrificed to provide food for a human. Those in the developed world have distanced themselves from where their food comes from and from nature itself. Whether or not a person attends the slaughterhouse from which their neatly packaged hamburger comes, the animal is sacrificed for them nonetheless. A modern Westerner has an unknown company kill their food and ship it to their supermarket. The Maya up until recently have had to kill everything they ate. Mayan ritual sacrifice is performed to permit survival and preserve health and well being, not for amusement.

Sacrifices are used in ceremonies to call ancestors for guidance and to thank ancestors for their aid. If a visitor comes to a Westerner's house they are offered food and hospitality. In the same manner, if a Mayan ancestor comes to help, they are offered sustenance often in the form of a sacrifice. The K'iche' do not believe the dead can eat food but they do believe the dead can take in the smell of food via smoke. Sense of smell is believed to be the sense most easily transmitted to ancestors and calls them into the fire. Different ingredients that burn in the ceremonial fire leave a different smell that sends a particular signal to ancestors. Incense is used on a daily basis independent of the fire ceremony to summon ancestors. Similarly, incense used on a daily basis has a variety of scents, each of which conveys a different message to the dead.

"Xicay" is the word for a symbolic punishment for those who break their word or do not fulfill their role in the K'iche' community. In the fire ceremony a participant receiving Xicay is hit with a rod of plant fiber often on the backside. Xicay is also practiced on those that are ill if transgressions are believed responsible for the illness.

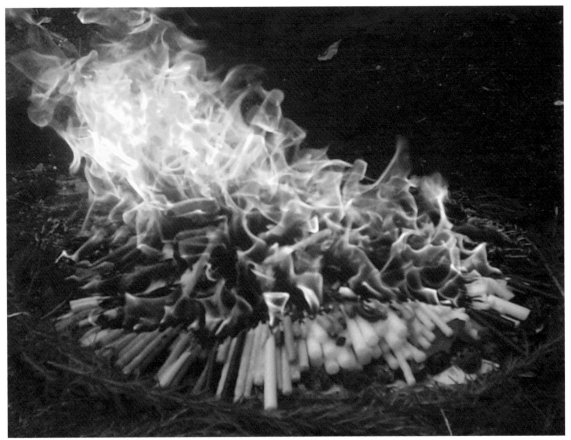
Mayan Ceremonial Fire

Westerners analyze rather than interpret natural phenomena. Westerners view natural phenomena such as the weather as problems, which are then divided into sufficiently small pieces to permit analysis by reason and logic to see trends that are predictive in nature. This means processing in the conscious mind since the unconscious mind is not believed to be capable of reasoning. The scientific method is a highly structured example of the use of refined Western analysis to interpret the world around us. Westerners regard the Mayan interpretation of natural phenomena by instinct and the unconscious mind, as too imprecise of an interpretive tool to solve problems.

Sense of time is largely an unconscious perception. Perception of time is not taken into account in the analysis of many cultures but is one of the keys to understanding the cognition and behavior of the K'iche'. Like a drumbeat in the background of life, perception of time sets the rhythm for life. The Maya perceive time as moving backwards, Westerners perceive time as forward moving. The Maya consider themselves part of the past while the Westerner looks toward improving their future. To the Maya what "has happened" matters, to the Westerner what "will happen" matters. The dead are always with the Maya supporting them in their time of need. Westerners are haunted by their dead and try to forget their own mortality.

ANCESTORS, PRIESTS AND HARMONY

This is from an interview with Maria Cortez about an event that occurred 60 years ago:

"When I was very young I was in charge of the sheep. In those days the people kept a lot of sheep. Now they mostly have cows or just corn and beans. I took the sheep into the mountains to get them grass. One day at five in the afternoon a coyote appeared. Legends say that whoever looks the other in the eye first, either the coyote or the man, is frozen. That coyote looked at me and I froze, unable to move. The coyote attacked and ate one of the sheep. I returned to the house crying and told my mother and father a coyote had eaten a sheep and I couldn't move or do anything because I was frozen by the coyote. My parents were very angry and took me to the Mayan priest for punishment "Xicay". My parents wanted to give me the most severe punishment they could, which was public humiliation. A woman has to lift up her guipil (blouse) and receive blows on the back with a special yellow stick that comes from the "membrillo" tree. The "Aj Q'iij" (Mayan priest) had a Mayan ceremony and in the flames of the fire and the Tz'ite (counting of the sacred 260 red beans) found out what should be done. The fire and Tz'ite told us that the mountain had sent his coyote to eat the sheep because we had never thanked the mountain for all the grass it gave to the sheep. Instead of punishing me the priest told my parents that he would need to punish them for not showing respect to nature. The next day my parents went to the mountain with the Mayan priest to pay the mountain with several fat roosters. They made a ceremony in the mountain to thank it for the abundant grass it gave to the people's sheep."

Testimony:　**Maria Cortez**
Age:　　　　**71**
Village:　　**Chilima**

The K'iche' attach much importance to dreams and natural occurrences and perceive them as signals or warnings. Close examination of natural phenomena such as a volcanic eruption or earthquake as well as more ordinary events such as a nightmare or seeing an owl fly past, provides interpretation that help guide the K'iche' in their daily life. The K'iche' interpret natural phenomena using instinct and feelings that come from experiences stored in the unconscious portion of the human mind.

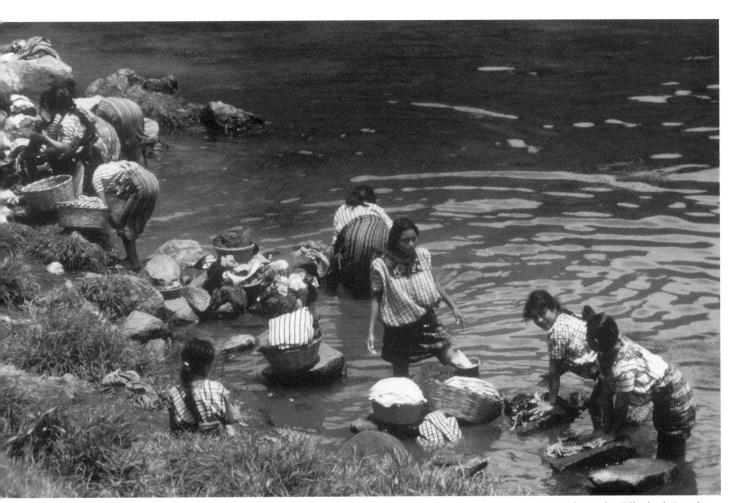

Highland Maya Women Tending Sheep and Washing Cloths.

Photos by Elizabeth London

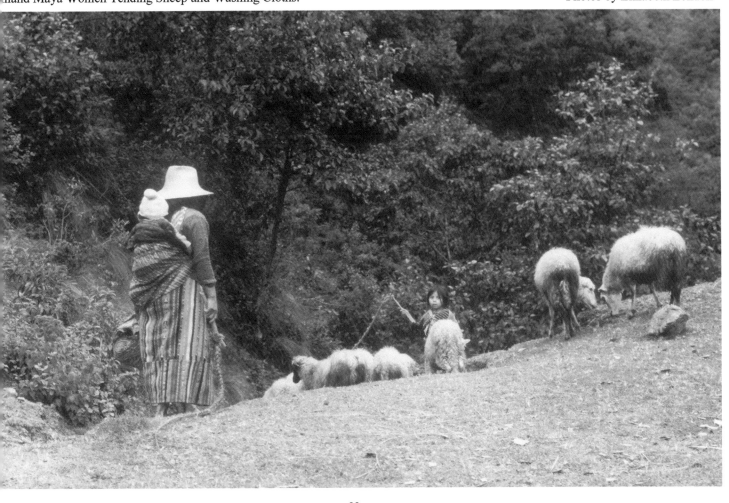

WITCHCRAFT

Witchcraft in Guatemala is not an organized religion nor do Mayan priests approve of it. However, there are those in both the Ladino and Mayan populations in almost every rural community in Guatemala that do practice witchcraft. It is not clear whether the origins of witchcraft have more of a European or Mayan origin. Witchcraft was widely practiced in Europe at the time of the Spanish conquest and passed over to the North American colonies as well as the Latin American ones. With the rise of science, witchcraft is no long popular in Western countries. Witchcraft is an everyday reality in Guatemala and much of the developing world. Few Western visitors realize how common the practice is.

WITCHES AND VIOLENCE

From journal entry from Douglas's 1989 journal,
San Luis Jilotepeque, Jalapa, Guatemala

I was working with a Pokomam leader, Pablo, in El Cameron, a village of 4,000 Pokomam, nine hours horseback ride from my house. I was working on the construction of a village water system. Cameron had no local access to water, so the people had to climb down a canyon to a river and then haul all the water back on their heads that would be required for drinking, bathing and all other uses. All told, a two hour daily ordeal. Pablo was very eager to secure water to help his village. Pablo sacrificed many hundreds of hours leading his community and organizing a project to bring water to his town. I provided the design and materials and Pablo organized the townspeople to build the communal water system. In 2006, this water system is still providing water to the village.

I admired Pablo and considered him exemplary. I was surprised to learn that one day Pablo had gone out and shot and killed his neighbor, Manual, in broad daylight. I later was able to talk to friends in this Pokomam community and piece together what happened.

Pablo had a wife who was dying a painful death from a chronic disease. According to village leaders I talked to, Pablo's neighbor Manual had had a land dispute with Pablo. Manual went to a local witch to have a spell put on Pablo. The witch provided Manual with appropriate "equipment" and advice to create a spell. Pablo believed it was the neighbor's spell that was responsible for the great pain and suffering his wife was enduring. To save his wife he shot the neighbor he believed was killing his wife.

In Western medicine, a placebo effect occurs when belief alone and not an actual treatment cause physiological changes in the patient's health. Witchcraft can function as a powerful placebo and be a very effective weapon against enemies. When it is used against a victim, the victim's belief in witchcraft's power creates real physiological effects. A victim can be frightened and intimidated and even physiologically killed by witchcraft alone. Even today, fear of witchcraft can initiate a chain of violence in which persons who do not practice witchcraft are accused of being witches, leading to violence. To view witchcraft as merely superstition is inaccurate. Witchcraft is widely used today in most of the world and is in fact a very effective weapon and deterrent. Perception is often more important than reality in individual conflict and conflict resolution.

While Mayan priests do not engage in witchcraft any more than evangelical pastors do, Mayan priests must deal with the fact that the people attribute supernatural and magical causes to disease and misfortune. Thus, the Aj Q'iij must find peaceful solutions to resolve individual conflicts within the community caused by witchcraft. Mayan priests receive years of rigorous and meticulous training as apprentices under an experienced Mayan priest to prepare them to deal effectively with community conflict. One the Aj Q'iij's many duties in training is to acquire enough experience in Mayan counseling and psychology to resolve personal and societal conflict caused by magic and witchcraft. In cases of witchcraft, the Mayan priest's role is to resolve community conflict caused by the practice of witchcraft to avoid damage to the Mayan social fabric. Through structured ceremony, the Mayan priest provides interpretation of events attributed to supernatural causes and magic that help the community to maintain harmony with both their neighbors and nature.

Without the institution of a formal Mayan religion and its priests, internal disputes involving weapons like witchcraft threaten Mayan community institutions and Mayan norms. The lack of sufficient Mayan priests and their religion to protect Mayan norms is a serious factor in the present erosion of the Mayan culture. Religion plays a critical place in all societies. Those interested in preserving Mayan society need to support the underlying social support systems. Permitting training of the Aj Q'iij without religious prejudice or violence is vital to the survival of Mayan society. Mayan priests, traditional Mayan midwives and other Mayan social institutions need to be free to be able preserve the two thousand-year-old cultures of which they are an integral part. Westerners believe they can select aspects of culture they find attractive and suppress others aspects that may conflict or offend Western sensibility or religious belief and still preserve diversity. This, unfortunately, is the unacknowledged philosophy in most international religious and even secular development programs working in developing countries like Guatemala.

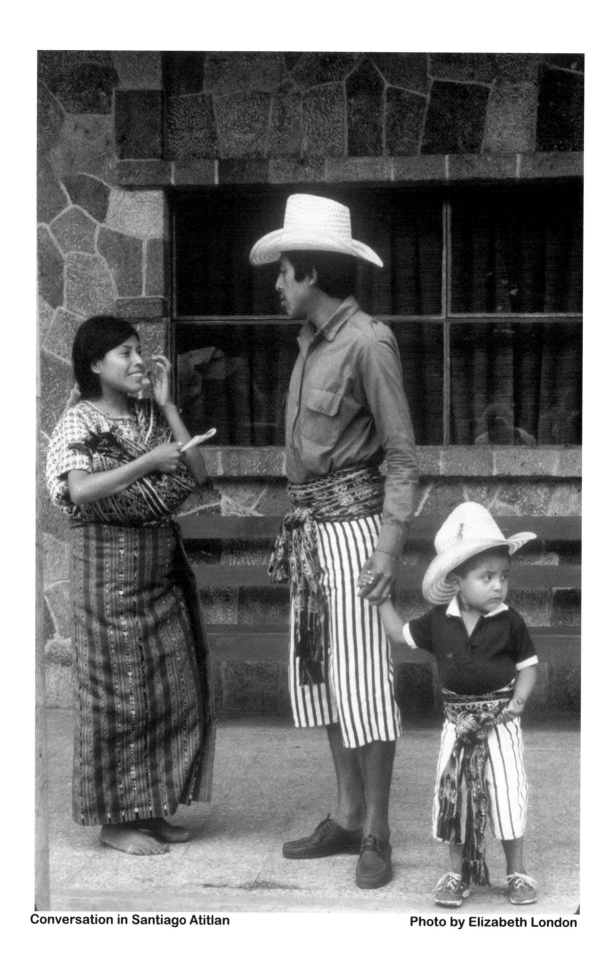

Conversation in Santiago Atitlan **Photo by Elizabeth London**

MAYAN COURTSHIP, MARRIAGE, BIRTH AND FAMILY

MARRIAGE

In traditional K'iche' society, the marriage is proceeded by one year of courtship. The father of the male suitor visits the house of the potential bride with a ceremonial basket of bread. If the father of the bride accepts the basket of bread then the marriage will take place. This is providing the future groom shows proper respect to the family of the bride. The male suitor offers one year of free manual labor to help the family of his bride to be. During that year before marriage, aside from manual labor, the male suitor must also bring specific ceremonial offerings to the woman's family at particular times during the year. Offerings start with a symbolic basket of bread, meat and beverages for the family. Every four months the man must come to his future wife's family with a new symbolic offering. This sacrifice establishes respect towards the woman, which forms the foundation of the marriage.

A married couple in the USA or Europe will have to face life with less family and community support than in Mayan or Ladino culture. The intensive process of dating to find the most compatible partner is more critical for Western couples who will be more isolated from family and community support than their counterparts in Guatemala. The Western marriage process inherently puts more stress on the couple. The modern Western idea of dating and trying to find the best fit for a marriage partner is unpopular with Ladinos and prohibited by the Maya. In the case of Ladinos there are usually a number of exclusive boyfriends or girlfriends before the individual gets married.

With the K'iche', community plays an important part in stabilizing and supporting marriages. Thus, the K'iche' spouses' compatibility is a less critical factor than in a Western marriage. With Ladinos, family rather than community are the key stabilizing factor in marriage. In a Western marriage the principal form of support is the respect the couple gives to each other. Marriage for the K'iche' is a union between two families. The union between the two individuals to be married is secondary. The responsibility for the success of the marriage rests on the community rather than the couple. On the other hand, Western marriages emphasize the union of two individuals, the relations between the respective families being secondary.

Divorce does not exist in Mayan culture. Divorce is not popular among Ladinos. On the other extreme, in countries such as the United States, the divorce rate is up to half of all couples. Even though half the population's marriages end in divorce, Westerners view divorce as a failure of the married couple rather than a flaw in the society.

A Western couple must survive with minimal family and community support and are often employed far from relatives. Western couples and individuals tend to rely on a system of friends, typically not connected to the family or community. Friends and the institution of friendship as a support system, normal in the modern West, are far from a universal way of life in much of the non-Western world. Most Westerners fail to realize this. Although the traditional K'iche' form friendships outside the family, friendships are not a source of significant emotional support.

Another support system for isolated couples and individuals in the West is psychotherapy and counseling which fills some of the vacuum due to loss of extended family support. One of the advantages of psychotherapy and counseling is that it provides far more objective support than advice originating from Mayan or Western family members. Unfortunately, therapy usually puts the responsibility squarely on the individuals to resolve their differences with little emphasis on finding outside support (other than expensive therapy) to save a marriage in jeopardy. From a Westerner's point of view, extended family support is often viewed as interference and considered an invasion of a couple's privacy.

BIRTH

In the event of a pregnancy out of wedlock, the lion's share of shame and blame in Ladino/Western society traditionally falls on the woman. In stark contrast, the K'iche' blame an out of wedlock pregnancy on the man. Thus, it is the parents of the man that are accorded more embarrassment and shame than parents of the woman. The K'iche' believe that the fault lies more with the man's family because they did not respect the woman's family and took advantage of the situation. When a pregnancy outside of marriage occurs, the father of the man responsible asks the "Kamol B'ey" (community referee usually a respected married couple) to serve as an intermediary with the father of the pregnant woman. Marriage is arranged after the couple kneel and ask forgiveness and permission to marry from both of their families.

Birth is a natural event that has great symbolic and religious significance for the K'iche' and the birthing process is communal in nature. The birth experience is viewed by the K'iche' as a way to bring both the couple and their families together and resolve their differences before the baby is born.

"Baby" by Tax'a Leon in acrylic paint.

In contrast, a Western birth is more of a medical and individual event and it is only recently that fathers were allowed in the birthing room. During a K'iche' birth the "Iyomab" (midwife) serves as a counselor between husband and wife and their respective families. The recent medical role of a Iyomab is a mixing of Western medicine and Mayan tradition. The midwife is there to resolve any resentment and problems that the families believe are causing difficulty with the birth. If childbirth is not rapid the Iyomab moderates between the families to find out if there is anger and resentment between the pair that needs forgiveness.

The birthing process can be harsh on a Mayan woman with a difficult birth. Even a woman in great pain will be questioned by the Iyomab about personal wrongdoing in front of her husband and requested to reveal and seek forgiveness. The husband in turn is requested to explain any of his own personal wrongdoing and seek pardon. The K'iche' believe difficult births are caused, in part, for psychological reasons such as guilt and on the spot "therapy" to achieve forgiveness is critical to save the mother and child during a difficult birth.

FAMILY

The "Pixcab" (respect) accorded to individuals by their Mayan family is very clearly defined by the order in which they were born. K'iche' families in the past were typically large, so the hierarchy of authority by order of birth spanned many decades of births. Older brothers and sisters are respected by younger ones even if there is only one year difference in age and one is 91 years old and the other 92. The respect is lifelong and permanent. Upon marriage the K'iche' have the opportunity to establish a new hierarchy where as parents they will occupy the seat of highest respect.

TAX'A'S FAMILY

"My family has twelve brothers and sisters. It is discourteous for me to advise an older sister but my older sisters are expected to tell me what I can and cannot do. Brothers have more authority than a sister of comparable age does. Twins have a revered place and are accorded special respect. The heroes of the K'iche' story of creation, the Pop Wuj are twins.

The architectural structure of a traditional K'iche' house is a good example of their communal nature. A traditional K'iche' house, such as my extended family still lives in, consists of one large room for all activities including cooking, eating, entertaining and sleeping, with little privacy. This room is large enough to accommodate the entire family and has a storage room behind the house to store corn and other important goods."

"My generation has built a few smaller houses around the traditional house for more privacy than was the case in proceeding generations. The idea of dividing space physically with walls into separate rooms to create privacy is not a K'iche' architectural priority. The K'iche' family live as an interdependent unit rather than as a group of separate individuals with personal space, as is the custom in the West.

Authority within my family is demonstrated when the family eats together. When I go to eat with my family the seating appears unorganized and haphazard. But seating is reserved and fixed in nature and a younger family member cannot occupy the seat of an older one, even if they are absent. When I visited Douglas's family I noticed Douglas sitting in his mother's chair after having dinner. I mentioned that although it was not the case in the United States, in my society this was disrespectful."

The institutions of daycare and nursing home don't exist with the K'iche' because there is always a family member to take charge of the child or elderly parent. The Maya always take care of their children and elderly at home.

Money and careers are often prioritized by Westerners over personal care of their young children. Modern Western women frequently work out of the house even when their children are small. Day care, giving your child to strangers to take care of is an accepted Western practice. Thus, even when tiny, the Western child is already forced to be an independent individual. Westerners teach their children to be independent and fend for themselves from an early age. And that is what they do. The priority of individual freedom over family and community needs is a prime indicator of Western upbringing.

In Western society, elderly parents are rarely considered a asset by their children. Likewise, children are a financial burden on their parents. Thus, in terms of survival, children and parents look upon each other as a source of worry and concern rather than a source of income and peace of mind. Family sizes are decreasing in the West as children are increasingly viewed as a luxury rather than a necessity. Western children and the elderly, although regarded with much affection, are considered a burden to their families, having little support to offer the family in terms of survival, financially and otherwise. The built in isolation and guilt of the culture's youngest and oldest members takes a toll on the mental well being of Western societies.

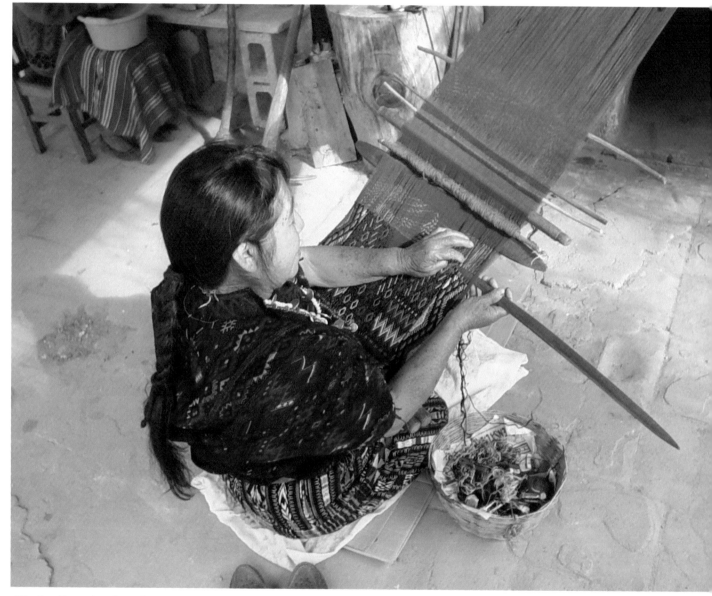

Photo: Douglas London

Weaving a K'iche' gu

The K'iche' look upon their elderly parents as an asset not a liability. K'iche' parents also look on their children as an asset both when they are young and able to work to help the family survive and later as the principal form of social security when they are elderly. More children means more security. K'iche' sons and daughters always take elderly parents into their own homes. The Maya know they can depend on their family to take care of them from birth to death. Westerners send their father or mother, who can no longer live independently, to grow old and sick and die in an institution rather than caring for them in their home. The Western rationalization is that institutions can provide better medical care.

To replace family support, the governments of Western nations often have an extensive program of social security to ensure the disabled and elderly receive the medical and physical support they need to survive. Often government social security is viewed by working taxpayers as an unacceptable burden on the individual who is earning income.

In K'iche' society, societal respect is gained through age and life experience. Thus, as the K'iche' get older, they gain more respect and prestige. The K'iche' do not gain respect principally by individual achievement. Thus, the K'iche' do not experience the high level of stress found in a Western individual who needs to compete successfully against others to gain societal respect. For the Maya, respect comes with age and all those that stay within the cultural norms of K'iche' society are guaranteed more respect from their family and community with each new year of life. A Westerner loses societal respect as they pass middle age and are no longer able to produce as much as when they were younger. Westerners fear getting older and fear dying. The K'iche' know that respect and a better life await them as they age. There is only one class of persons that receives more respect than the elderly with the K'iche'. That group is the dead.

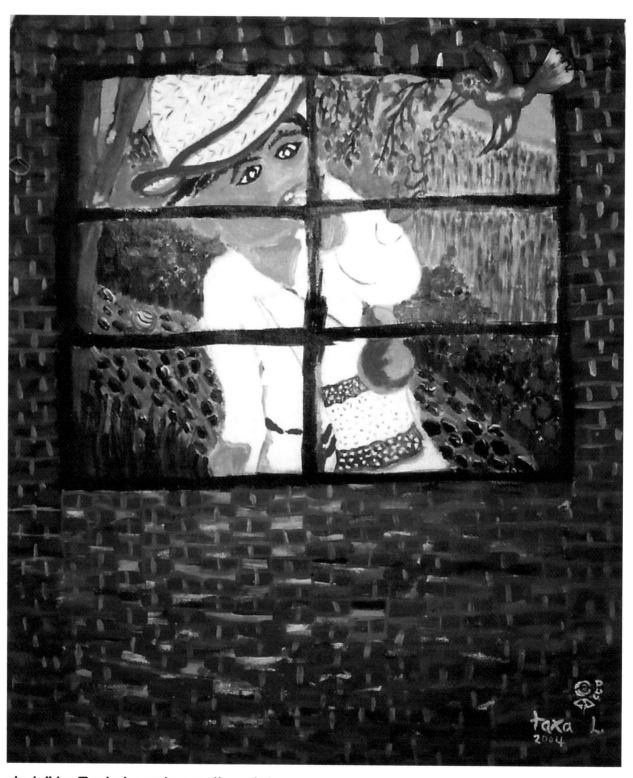

"Luis" by Tax'a Leon in acrylic paint.

Mayan punishments are designed to avoid revenge, bitterness or an escalation of violence dangerous to the community. Western law typically does not take these factors into account in judgment of a defendant. The K'iche' typically use restitution and repair of damages, obliged community service, detention and in extreme cases the sanctioning of public exhibition and embarrassment.

IT IS A SHAME LUIS STOLE CORN

Interview with Miguel, in which he describes what happened to his neighbor when he stole corn 55 years ago in his K'iche' community of Paquixic.

"The family checked the cornfields regularly to try to find out who is stealing the corn. At five o'clock in the morning they caught Luis. He had a burlap bag full of corncobs and he dropped the bag and ran. The K'iche' law of before for stealing in a community was to strip the person to the underwear and parade him through the streets. They brought Luis, this adolescent boy, in from the village to the next market day in Chichi (the main town). Luis had to carry a bag of corncobs while he was paraded through the town square on market day, in front of everybody. And they said as they took him through the streets, "this is the person that is stealing the corn from your fields". His family was shamed. Everybody in the entire community knew that Luis was a thief. This is the way they prevent a robbery in a K'iche' village. Luis was unable to get a job easily in the town after that and his family was talked about throughout the villages of Chichi. The villagers watched carefully whenever Luis was near their cornfields from then on. He never stole again. This was something that Luis and his family did not forget. Typically nowadays [under the Guatemalan State law] a robber spends a few days in jail, pays some money and is released. Nowadays people are scared to accuse a person of robbery because he will threaten to kill them."

Testimony: Miguel Lu'. Age 72. Village: Paquixic, Guatemala

K'iche' contracts are verbal in nature and based on "Pixab" (respect). Pixab is a powerful norm in Mayan society and the underlying principal for K'iche' conflict resolution. Respect is accorded to the "Ajaw" the creator and celestial presence. Also accorded great respect are nature, the family, the community, elders (including the dead) and local authority. For the K'iche' giving your word is not just a promise, it is the equivalent of signing a legal document in the West. Breaking your word is shameful and dishonorable and subject to legal sanction. The loss of respect for the institution of the word of honor would mean a breakdown in a critical system of Maya conflict resolution. A breakdown in the word of honor system opens K'iche' society to conflict and violence.

A CIVILIZATION DISAPPEARS

MAYAN LINGUISTIC/CULTURAL GROUPS

Q'eqchi', Itza, Mop'an, Q'anjobal, Chuj, Awakateko, Popti', Ixil, Mam, Tektiteko, Sipakapense, Tzutujilm, Kakchiquel, **Pokomam,** K'iche', Sacapulteco, Uspanteko, Pokomchi', Xinca, Chorti, Achi'

The Pokomam nation, over the centuries, had been reduced to an isolated group of Maya in a desert region of Jalapa, Guatemala, far from the main Mayan population in the highlands. From 1986 through 1989, as a Peace Corps Volunteer, I lived with the Pokomam and learned about their habits. My home was a simple adobe mud house and I bathed with a bucket of cold water each morning. I learned a fair amount of the Pokomam Mayan language from my neighbor and friend Santiago when he came over at night to teach me while I taught him some English.

No one came to the town of San Luis Jilotepeque unless they wanted to come to San Luis Jilotepeque, since it was on the road to nowhere. It was a nine-hour, rough and dusty bus ride to the capital. San Luis Jilotepeque was never a small place, the Pinula-Jilotepeque Pokomam population in 1986 was over 60,000 people. Yet, it was completely isolated and forgotten. No tourists ever visited San Luis. From 1986-1989 only one tourist visited the town, a German who got on the wrong bus. The tourists went to the highlands to see the Maya there. In 1989, San Luis had one telephone for 30,000 people, located in the town's central square. The next closest telephone was four hours away. The telephone was not used much, since nobody left town to live anywhere else, all family and friends lived in San Luis. The Pokomam had no need or cause to communicate with the outside world.

Mayan ruins surround San Luis. I visited at least 34 sites with the remains of significant Mayan buildings, all untouched by archeologists. San Luis has a number of large pyramids ("La Montana") not on any map. The remains of a Mayan religious ball court were clearly visible in one ruin ("El Durazno") in 1986. Most of the Mayan sites are disappearing physically as the people destroy the ruins on their property to avoid government seizure and other problems. Some of the pyramids in San Luis are large enough to qualify as small mountains making destruction difficult, so they still stand overgrown and hidden in the mountains in 2007.

In the center of town there is a beautiful Catholic Church built in 1690. It is one of the largest rural churches in Guatemala. There are also two huge Ceiba trees in the central square of town planted in the mid-1600s.

"San Luis Jilotepeque" by Tax'a Leon in acrylic paint

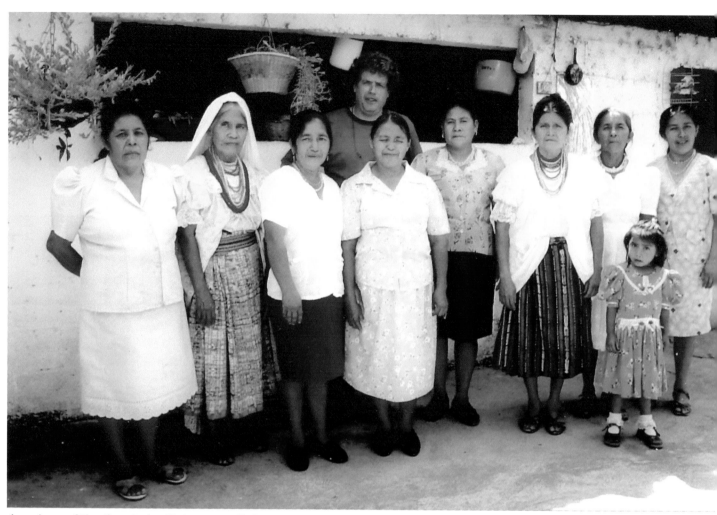

Leaders of the San Luis Jilotepeque Pokomam Potters Cooperative & Douglas.

Photos (one delayed action) by Douglas London

In 1986, the Pokomam women still wore traditional Pokomam Mayan clothing and made traditional pottery for family use. I organized a cooperative of Pokomam women and we bought land containing clay mines. The traditional clay and paint mines were exhausted and the only remaining areas were now private property. Our cooperative's purchase of the clay mines helped to assure the continuance of traditional pottery making for almost 15 years. Other Mayan "industries" in San Luis included the mining and construction of corn grinding stones and the making of stone water filters. Now traditional clay water jugs have been replaced by plastic and stone water filters are no longer in use.

I bought a horse to permit me to travel through the rugged terrain that led out to the distant outlying villages in which I worked. I worked with the Ministry of Health to train a new generation of Pokomam health promotors. I helped organize and fund the construction of a number of rural schools, village electrification systems and town water systems. I also helped the Pokomam organize numerous small agricultural businesses and cooperatives including chicken farming, coffee production, bakeries and adobe oven construction. All these projects allowed me to spend a lot of time with the Pokomam Maya and get to know them well. I worked closely on many projects with an unofficial Pokomam counterpart, Feliciano. He and other Pokomam elders taught me a lot about the Pokomam way of life during my three years in San Luis.

I revisited the town of San Luis Jilotepeque in 2005 for three weeks. In many ways it was a sad visit. In 1986, the Pokomam from San Luis Jilotepeque and neighboring San Pedro Pinula were a vibrant culture. In 2005, for all intents and purposes, the Pokomam were gone. I was the witness to the death of an entire culture in the space of only 18 years. The new generation of San Luis had turned their backs on their language, clothing and tradition and expressed shame in being identified as Pokomam. The older generation had become fearful of being identified as being Pokomam, many referred to religious pressure as the reason they were hiding their cultural identity. The destruction of an entire culture I knew and cared for is one of my motives for writing this book with my wife.

What could have destroyed the Pokomam in the space of two decades? The Spanish and their ancestors failed for almost 500 years to take the Mayan out of the Maya in San Luis. New religions arriving in San Luis and Guatemala have discouraged Pokomam and Mayan indigenous identification as non-Christian. However, the Pokomam withstood almost 500 years of violent religious persecution, it doesn't seem credible that these new voluntary religions could be more effective in destroying the culture.

San Luis is a different case than the highland Maya and an illustrative one. The Guatemalan government and military have not interfered significantly with the Pokomam for over a century. Only for a brief period in the 1950s did the army help the rich landowners take property President Arbenz had distributed to the poor.

The people of San Luis rarely traveled outside of San Luis and outsiders did not come to visit so there has never been much direct outside contact. Many San Luis women, even today, have never traveled further than the adjoining towns. Almost no one from San Luis left the town to work or live elsewhere with the exception of some young men that have gone to the US to work in the past few years. Almost everyone I knew 18 years ago was still there or in the town cemetery.

An interview with Gomez Augustin a former Pokomam leader in the village of Pampacaya:

"All the foreign aid is going to the highlands. We are forgotten. There was no war here other than a few young men the army could catch. They were kidnapped by the army and forced to kill the highland Maya. Nothing happened to the Pokomam so we get no foreign aid. After the war some former soldiers brought back pistols but they only shoot each other. The army was never here."

So what has caused such a swift and dramatic collapse of the Pokomam culture? There was almost no Western or outside influence for the past century. Likewise, the Guatemalan military had not been a significant presence in the region for a century. Religious pressures were there to be sure, like the rest of Guatemala every block seemed to have a church. But for the last 450 years there had been similar religious pressure exerted on the Pokomam in San Luis.

To try to find the answer I studied the lifestyle of many of the new Ladino, (formerly Pokomam) families during those weeks. The adults that I visited to conduct my informal study had their time divided into three main activities, work, church services and television. Evangelist church services took up four nights of the week and most of Saturday. Then it occurred to me. There was an outside invader I hadn't thought about principally because it wasn't a human being.

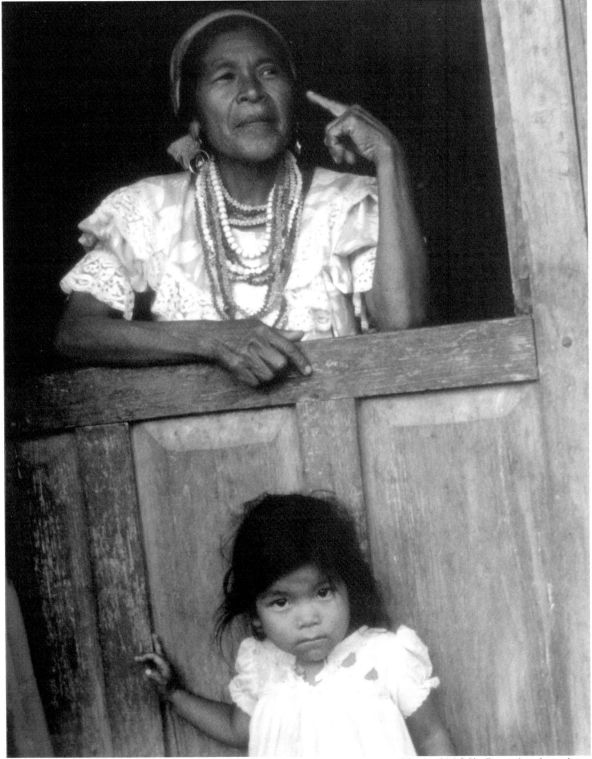

San Luis Jilotepeque Potter

Photo (1986): Douglas London

A decade ago Ladino entrepreneurs installed satellite dishes and sold pirated television to the community. Before that, most houses had television antennas. The Pokomam may have had no food and only the clothes on their backs but every house, almost without exception, had a TV. Even the simplest corn cane mud hut with only plastic bags for a roof had primitive electricity and a television set.

Over the month I spent in San Luis, I noted the television watching time of 12 families. In these families, television occupied an average of 4 hours a day of both the adults and their children's time. If consistent over the past decade that would add up to up to almost 1825 hours of television watching per person, per year or 18,250 hours of TV over ten years. That means my friends, over the last ten years, spent an astounding 2 ½ years of their waking and sleeping time watching television with only 7 ½ years left for all other activities. Other families appeared to have similar TV watching habits.

From the many conversations I had, it was clear that the people of San Luis formed their impressions of the outside world largely through television. They had no real life experience of the outside world to balance what they saw on TV. In San Luis, television combined with intense religious pressure helped provide the final push to put the declining Pokomam culture into oblivion forever. Is television a more effect destroyer of culture than all the steel swords of the conquistadors and their descendents throughout 400 years of occupation of the Pokomam homeland? There are still no tourists visiting San Luis in 2005. The entire Pokomam culture had died without even becoming known to Westerners. I only know that I feel a great sadness and emptiness now that the Pokomam are gone.

"Time Travel
Through
Guatemalan
History"
by Tax'a Leon
in acrylic paint

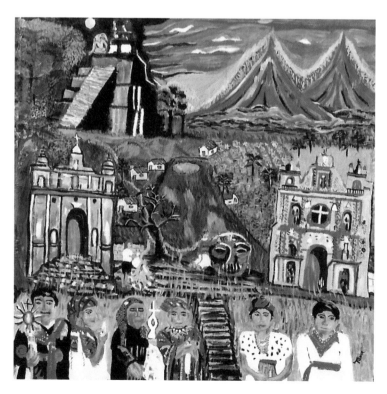

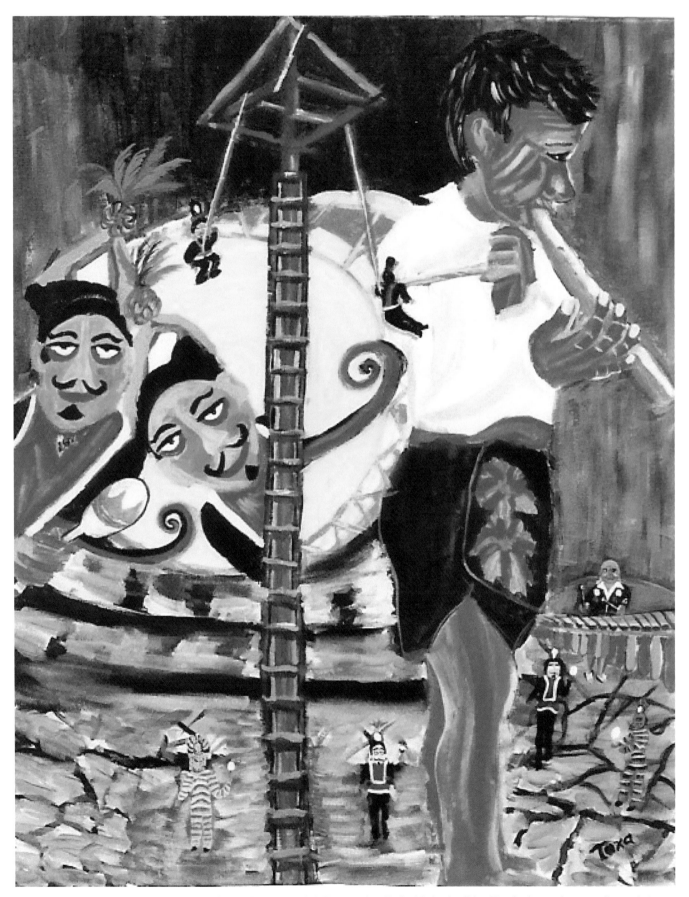

"The Vanishing Maya: Players of the Ceremonial Sport the Palo Volador" by Tax'a Leon in acrylic paint

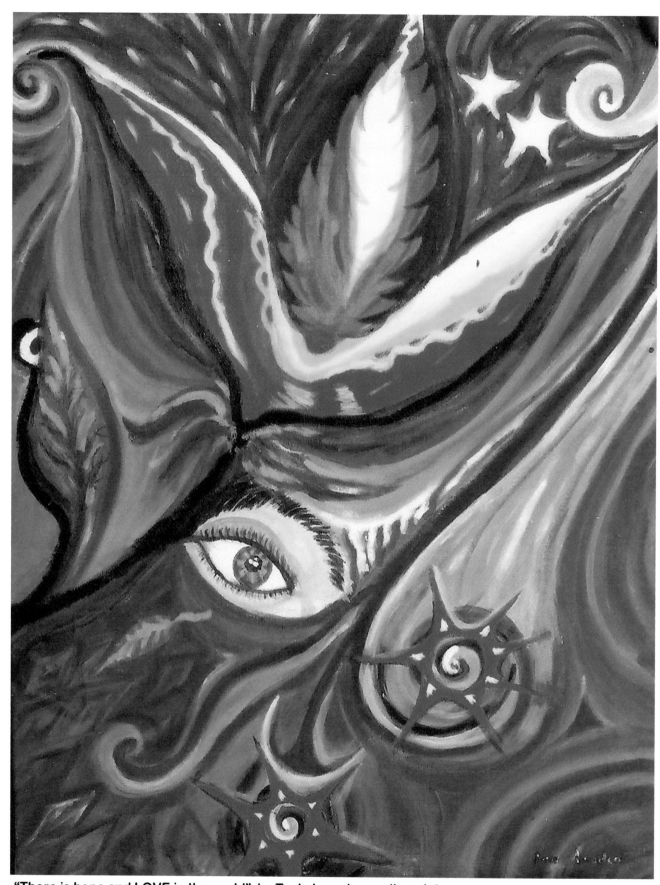

"There is hope and LOVE in the world" by Tax'a Leon in acrylic paint

Our church, our candles, our sacred bible gives me hope that opens
a window to a better Guatemala.

Title: Paz por La Ventana
Artist: Juana
Age: 10
Medium: Oil Crayon

SECTION IV: SHAME, GENOCIDE & CHILDREN

A MESSAGE FOR THOSE WHO WISH TO DO GOOD

Amid the color and beauty there is darkness. In Guatemala there are things that everyone knows and no one says. How is it possible that in the aftermath of such widespread violence including the torture, mutilation, murder and rape of countless children and adults whose numbers are in the hundreds of thousands there is only a long silence on the part of Guatemala's millions of affected families. Fear of reprisals does not fully account for this phenomenon. In a population of millions, in any society, there are courageous people willing to take risks. Another factor is in play here, a more subtle but perhaps more resilient emotion then fear.

The one universal feeling that all this book's participants expressed was shame. One of the major outcomes of the trauma inflicted on the Maya seems to be shame. The perpetrators of the violence, the upper-class and the higher army officials of that era who have a genuine reason to feel ashamed of their behavior may well experience much less shame than their victims. Humiliation, helplessness and guilt have been welded into an extreme form of shame. Shame is the overriding emotion that maintains the secrecy here.

Much can be learned by studying extremes of human nature. Shame may be the single most powerful long-term human motivator or deterrent and can consistently over time, override all other very powerful emotions, even love, hate, fear and anger. Shame is as much a societal as an individual emotion. Shame maintains societal norms but at the expense of individual freedom. Other emotions are volatile, shame stays and exercises a consistent influence on all decisions made. It seems that it is possible not only for an individual to be traumatized but also for an entire society to suffer a form of collective post-traumatic stress disorder. The Maya have been traumatized into silence. When shame, guilt, fear and resentment walk hand in hand with malnutrition, illness and poverty it paralyzes the individual spirit.

Later on we discuss why humans have shame and what purpose it serves for humanity.

Ixil Maya Guipil (woman's traditional woven blouse)

For those in the field of international aid and development working with the Maya in Guatemala and especially those who write grants to fund these programs perhaps this book can offer insight. Investing time and money in programs and projects will not lead to success in helping the Maya if the underlying problem of lack of societal self-esteem is not taken into account. In fact, some of the well-intentioned international development programs in Guatemala ironically may actually undermine the society they seek to help by confirming in the minds of the population that they cannot help themselves. People in a position of weakness feel shame in accepting outside help.

Coming in with a preconceived plan and program which the participants had no fundamental part in designing is sending an unintended message, "we know what is best for you". The Maya are no different than other people around the world, they need to regain self-esteem if it has been damaged. Self-confidence is a key catalyst in invigorating a society into self-development. Development is not something we "do" to somebody, development is stimulating the person or culture to take charge and do it themselves. Those working to help the Maya and other indigenous civilizations should ask themselves two questions.

1) Have the people you are trying to help participated in the design of your program or have you imposed it on them? For example, has your organization designed your program without the majority of the program design input coming from the people it is supposed the help? Or have you modified and transplanted a program that was perceived as "successful" elsewhere? If you have done either of the above, you have imposed an aid program. The message you are sending is we know what is best for you and you Maya do not have the competence to take care of yourselves. Other cultures and people are not underdeveloped Westerners and culturally inappropriate development programs are sadly the rule rather than the exception.

2) Does your program provide faith in their own culture, religion and way of life or are you providing something "better" for them. In other words, will the program leave the participants and the society convinced they have something important to offer the world, that they can someday come to the US and offer us assistance, or does it reinforce inferiority, that they are so badly off that they can't even help themselves.

Remember the physicians' creed: first make sure you do no harm. In evaluating a international aid program one should not automatically assume the program was more helpful than damaging. The potential for damage should be evaluated, many aid projects may fail this most basic criteria.

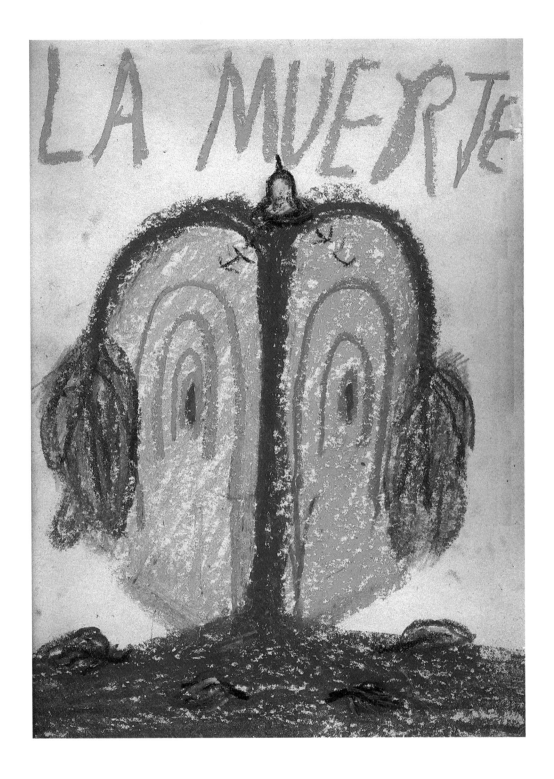

The tree is broken into two branches, both collapsed and the roots do not grow like other trees, why has the tree stopped growing? Because it hurts, like someone you love has died, death has cut it short.

Title: El Arbol Truncado
Age: 13

Artist: Lesly
Medium: Oil Crayons

Mayan Boy

Photo: Douglas London

THE CHILDREN

A system only changes when all parties see it is in their self-interest to change it. A successful alternative for Guatemala must provides a win-win situation for the poor and the wealthy, the Maya and the Ladino. Children represent Guatemala's best hope for the future, their minds are still open.

In school, children need an explanation, not just memorization of facts and figures. Tax'a's art students in one of her art classes painted the children's pictures in this book. They were not prompted, other than told the topic was the armed conflict in their homeland. The results can be seen in this book. Children need to be taught to think and deal with their feelings. Facts are of no use if children don't develop the judgment and wisdom to use them. Children are smarter in many ways than adults, learn faster and have not learned to be close minded yet. Adults have formed permanent stereotypes from which they simplify and often distort life's complexities. Creativity, not memorization is the highest form of intelligence. A creative population will find solutions to poverty and violence.

Below is a wish list of important topics for inclusion in the school systems of Guatemala. We realize that practical and political barriers may make implementation difficult. The reason we chose to include them is to stimulate thinking on the topic through real examples rather than generalizations.

CONFLICT RESOLUTION

➢ Study the concept of a win-win scenario as an alternative to the Western model of competition and the implied win-lose scenario. This can be effectively taught at a child's level. Most Guatemalans are not aware that there are alternatives in conflict resolution in which both parties come out ahead. The win-win concept is critical to developing a child's concept of nonviolent conflict resolution early in life. Many conflicts can be settled in a manner that preserves dignity and positive change for both parties.

➢ A course on what human trauma is and how it effects a person. Self-understanding is important for children's mental health and provides a base for understanding their own feelings. This in turn provides a basis for understanding others as it is difficult to empathize with others if you fail to comprehend your own reactions and feelings. Improving social skills starts with grasping the point of view of others. Development of the next generation's ability to be empathetic is key. The more skill the next generation has in understanding other people and their motives for actions, the better the hope for peaceful conflict resolution as an alternative to street violence and lynching.

➤ The importance of respect towards others is the next step after development of self-understanding and empathy. The Mayan culture emphasizes respect for others and community solidarity. These topics would also serve as an entry to appreciation of the Mayan culture. The Mayan norms have real practical value in today's world.

➤ Teaching the children how to talk to their parents about important issues. Lack of effective communication between children and parents is the pathway to ignorance and a vicious cycle of repeating errors in the raising and education of future generations. Each generation has to reinvent the wheel if parents are not willing to share their mistakes with their children. Have interested parents participate and form a national committee on improving family communication. Misunderstanding leads to violence between siblings and family members.

➤ Teach the value of telling the truth. Lying or hiding the truth prevents any possible positive change.

GENERAL COURSES

There are only three different career paths taught in Guatemalan schools, (secretary, accountant and teacher) to fill all the jobs of a modernizing nation. Having only three basic career options to fill the huge variety of skilled job positions needed to run an entire nation is foolish. More career options need to be created or Guatemala will never develop.

➤ We propose an annual national competition for children on the best ideas for the future of Guatemala. Using different media for the competition would allow children with different talents to participate. The first would be a written essay. The second would be some form of the creative arts without using the written word. The third would be the design of a scientific invention to improve some aspect of Guatemalan infrastructure.

**"Netting Fish"
by Tax'a Leon
in acrylic paint**

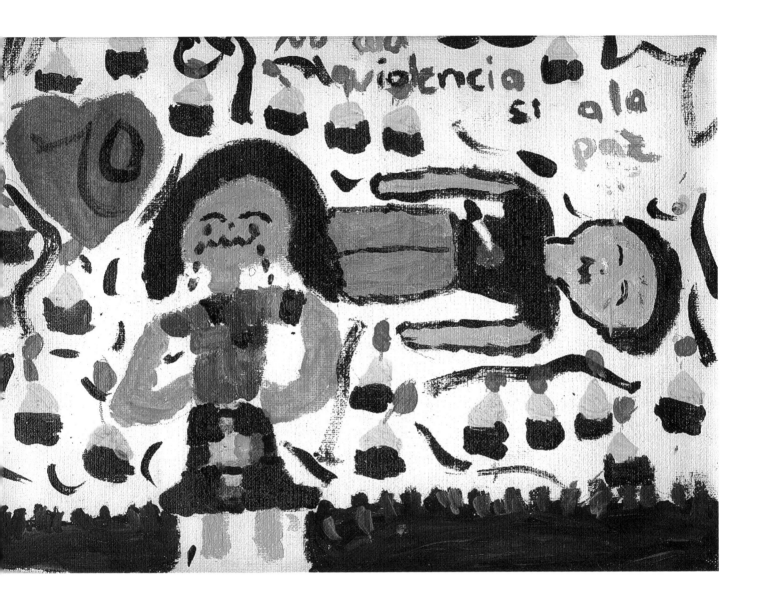

I want no violence or alcoholism or war, I want us to feel safe.

Title: **Me**
Artist: **Yoselyn**
Age: **10**
Medium: **Acrylic Paint on Cloth**

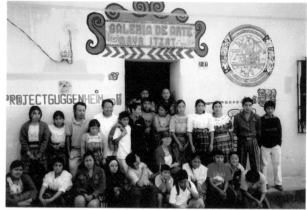

Douglas at the BrainRights clinic in Guatemala & our Itzat Mayan Art Academy, Chichicastenango

> Tourists play an important role in Guatemala. Tourists are witnesses. State sponsored terror is less likely to occur when there are tourists in the region. Tourists offer unintentional but significant human rights protection for the poor in Guatemala. Tourism is also an important source of income for Guatemala. Guatemalans need to learn how to treat tourists with more respect. They also need to learn how to keep tourism a positive not destructive force. We propose a national student competition to plan the best tourist projects. The key criteria would be designing a tourist program that would benefit the children's local community. Children come up with ingenious ideas that adults don't think of.

> We propose including a project in the school curriculum, for older students, on setting up and running their own micro-business that revolves around preservation of a tradition that provides income and thus respect and a practical way to assure that tradition's survival. Maintaining Mayan tradition without an economic base is not a viable option. Students need to learn how to make money within their indigenous cultural context. In addition, knowing how to administer a little business for extra income is a very valuable skill even if it is selling tortillas in the market place.

> Computer skills, especially the use of the internet, are essential for the new generation. Technology and modern communication appropriately harnessed can make social changes not possible previously in the history of humanity. This is especially true in underdeveloped regions of the world such as Guatemala.

> A national program can be implemented to take advantage of the abundance of foreign volunteers in the country. These volunteers can serve as guest speakers in the more remote rural schools. Foreign volunteers are an enthusiastic resource that already exists and only needs to be organized. This is an activity a foreign volunteer, with only a limited time to work in Guatemala, can do that will have a real impact. The volunteer, the children and the teachers would enjoy the interaction.

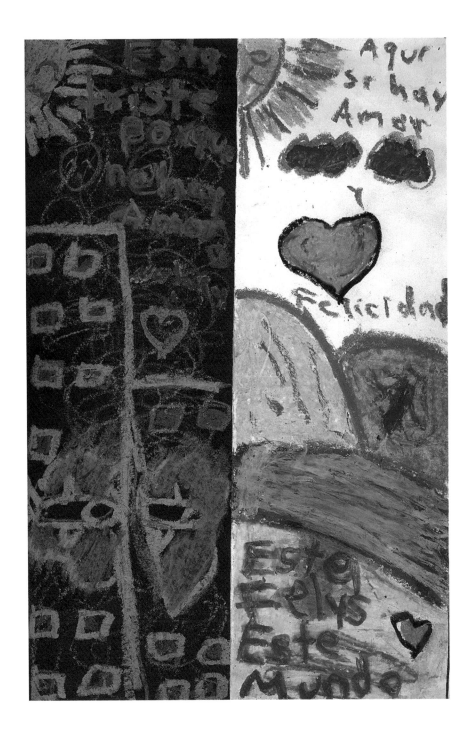

I am sad because there only exists everything covered in bad things, that happen in countries where the children do not understand, but I hope for a world full of color and happiness for children and people.

Title: **Las Torres Gemelas (World Trade Centers)**
Artist: **Yoselyn**
Age: **10**
Medium: **Oil Crayons**

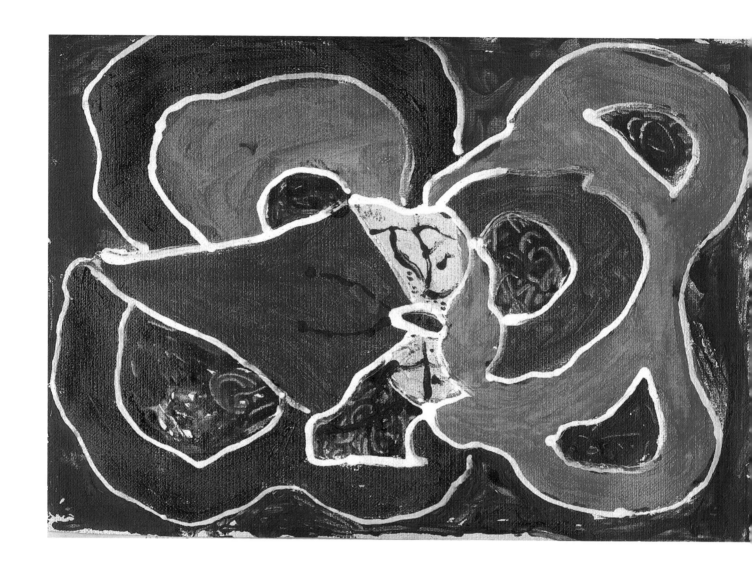

I like the color and light of butterflys, they make me happy and forget
all the sad things I see.

Title: Two Butterflys
Artist: Juan
Age: 9
Medium: Acrylic Paint

RESPECT AND APPRECIATION OF MAYAN CULTURE

➤ Student projects on the best way to protect local Mayan historical sites. Discussion on the value in protecting the thousands of Mayan archeological sites which surround almost every town in Guatemala. These majestic cultural sites are a visual reminder of the value of Mayan ancestry. It is important to make the connection between modern and ancient Maya since they are one and the same.

➤ A course on how to weave traditional Mayan guipiles (woven women's blouses). This would be an improvement over traditional sewing and tailoring classes presently available for women. Have Mayan women come into the schools and teach traditional weaving. Teaching traditional artistry is good for the self-esteem of the weavers and enjoyable for the children. A practical way to show rather than teach the beauty of indigenous tradition. Perhaps these classes could even be a small source of income for the weavers.

➤ Eliminate the damaging myth of Tecum Umam (ancient Mayan leader killed by conquistador Pedro de Alvarado) and other forms of subtle racism from the schoolbooks. Inclusion of Mayan history not just Ladino, American and European history in the school curriculum. Learning about Mayan ceremonies, the Mayan law of respect and word of honor and other positive customs will help reinforce the value of Mayan culture. These school curriculum changes are admittedly a very tall order for a country whose economic base depends on racism and a supply of cheap labor. However, even minor changes to the curriculum can curb violence and resentment and benefit all socio-economic classes.

➤ Initiate a technical career in writing and translating Spanish and English into Mayan languages. If the language is written and covers many subjects, it is more useful in the modern world and will disappear less easily.

➤ Last but not least, mandatory Mayan language study. Rather than just relying on government trained teachers, the wealth of cultural knowledge from the community can be brought into the classroom. Mayan leaders from the indigenous community could come into the schools to teach the children some aspect of their culture. A national committee of Mayan leaders could be formed to teach Mayan customs and language in the schools. Bringing customs alive for children is critical in preserving Mayan heritage and should be the most important component of any Mayan language class. Mayan leaders would be able to pass some of their experience to the next generation.

PARENT TRAINING

In a violent society such as Guatemala, it is crucial that parents limit the amount of television violence to which their children are exposed. TV portrays violence as a solution to problems rather than patience and hard work. TV makes light of violence starting early in life with children's cartoons where the characters strike each other with intent to kill. These violent acts are portrayed as amusing since the cartoon characters always return to life. Children's cartoons portray violent acts as a normal solution to conflict resolution. Cartoons and video games that promote violence as being amusing are not harmless, especially for children who have not learned to think critically.

TEACHER TRAINING

Any new topic requires teacher training. Without effective teacher training no class has a real chance of being successful on a national basis.

> We propose the organization of a national Guatemalan teacher committee to implement conflict resolution and cultural appreciation as an integral component of the Guatemalan school curriculum. A national committee of teachers interested in incorporating conflict resolution into the curriculum would be formed. The first job in adding new conflict resolution components to the children's curriculum would be educating the educators through a national teacher's training program.

The above-proposed changes to the children's school curriculum are suitable for nations beyond Guatemala including the West.

Below: Tax'a teaching art class in Quiche, Guatemala.

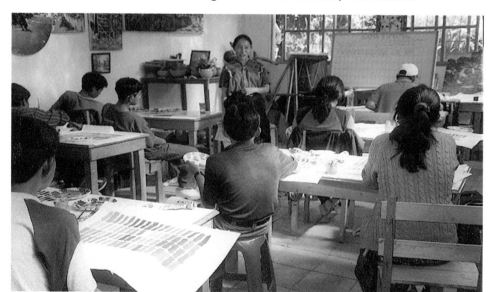

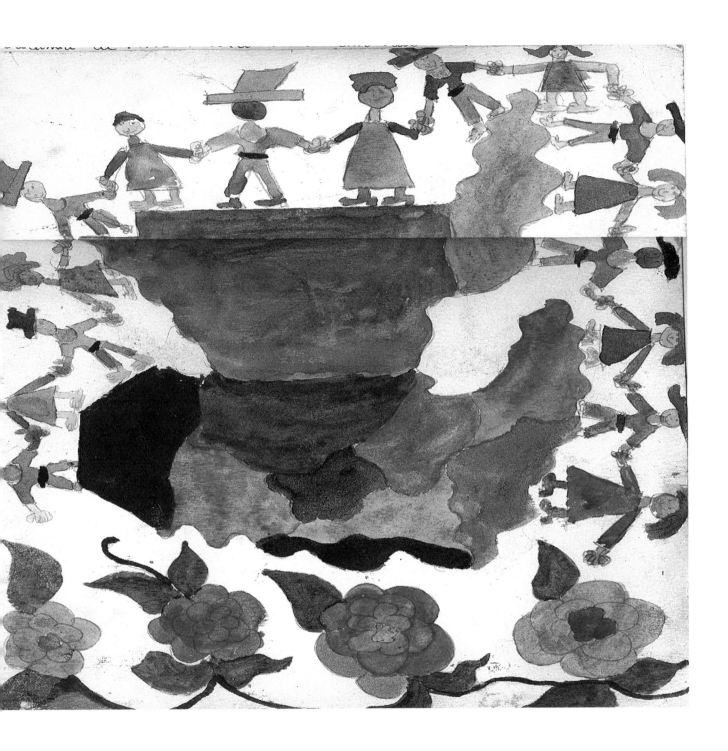

We hope for a better tomorrow where we will be happy and work together for our dignity.

Title: Trensadores de Esperanza
Artists: Felipe and Saira (wheelchair bound father and his daughter)
Ages: 32 and 5 years old
Medium: Watercolors

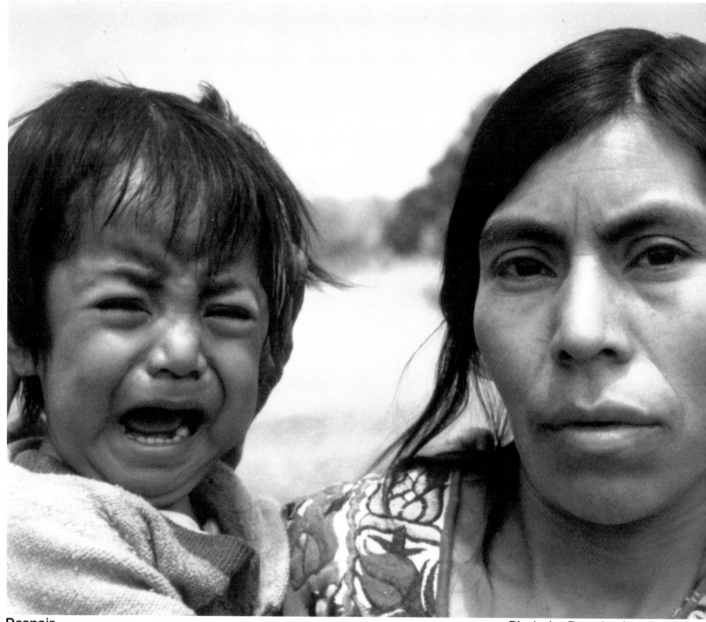

Despair

Photo by Douglas London

Conclusion: **K'ixb'al**

GENOCIDE: THE SHAMED AND THE SHAMELESS

"The line dividing good and evil cuts through the heart of every human being"
Alexander Solzhenitsyn, The Gulag Archipelago

Economic and political motivations only cause genocide in societies that are emotionally ready to commit genocide. Evil grows best in shadows. We must acknowledge the little bit of evil that exists in all of us. Societal pressure for conformity can quickly numb our individual ability to feel shame for "approved" acts of murder, torture and rape. These are evil deeds we are all capable of committing. If you think your personal moral fiber puts you safely across the line separating good and evil you will never see tragedy coming until it is too late. This book bears witness.

Violence has been a principal method for resolving conflict throughout humanity's history and remains so. For humans to organize and live together successfully a method of conflict resolution must be put in place to prevent societal disintegration. The key question in forming a stable society isn't "Why do we kill each other?' It is really the more practical, honest question "Why we should not kill each other?" Certain norms have to be in place, be they part of the fabric of the culture or in the form of written law to provide societally accepted alternatives to arbitrary conflict resolution. Thus, the real question we need to ask is not "why did the Maya genocide occur?" but rather "why are genocides not more frequent and what prevents their occurrence?". What successful barriers to this type of behavior do societies create and under what conditions do they function optimally?

This conclusion examines a Mayan solution to the problem of genocide, based on the Mayan norms and law that we have described in other parts of the book. The Maya place heavy reliance on K'ixb'al (shame and social isolation) as a preventative and punitive measure to enforce societal norms and resolve conflict. K'ixb'al has applications for all of today's world community.

Societies have emotions like individuals. If there were no overarching emotional links to bind people into society and motivate them into joint action there would be no society, only individuals in conflict. In all cultures, societal norms are controlled by shame. Shame and guilt are an individual's reaction to being viewed by their society as having violated social norms or failed to measure up to societal expectation. A powerful emotion, shame will predominate over other emotions such as ambition, fear, love and hate.

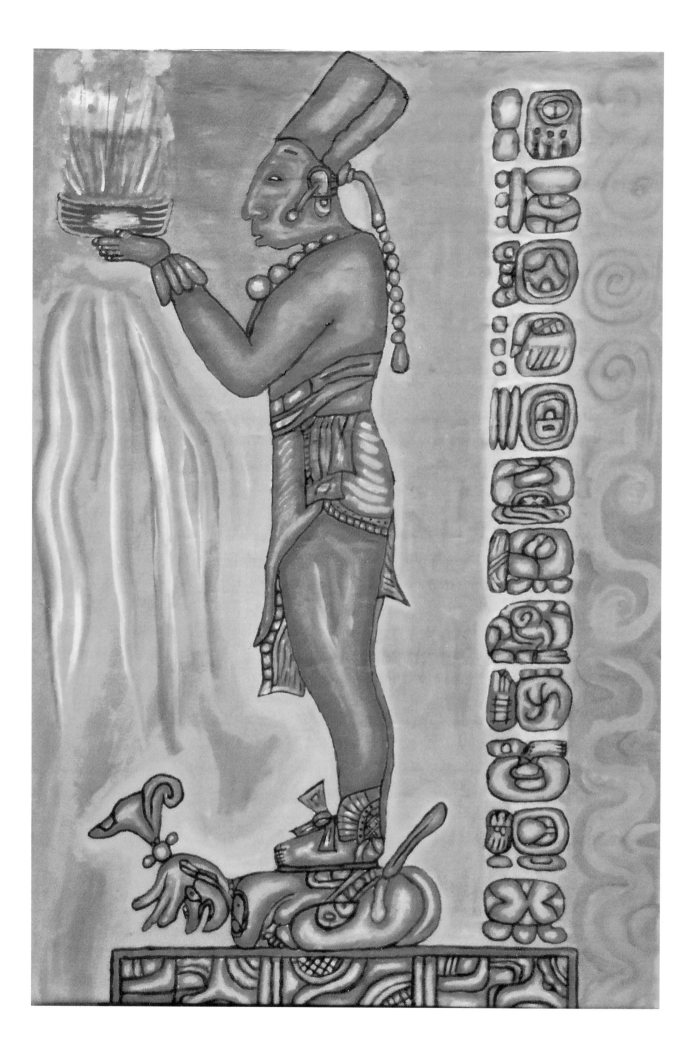

Without shame a society could not exist, as these more individualistic feelings would make conflict impossible to resolve. An extreme example of a person without any feelings of shame for their behavior would be a psychopathic mass murderer who is capable of killing without feeling they are doing anything wrong. Psychopaths are missing something in their individual psychiatric make-up that leaves them immune to normal societal brakes on behavior. What a psychopath lacks is the ability to feel guilt for actions that violate societal norms or shame for failing to measure up to societal expectations. A psychopath remains emotionally outside of the society they live in.

In a group setting shame moderates individual behavior, permitting humans to live together without killing each other when a conflict of interest arises. Shame protects a society from violence, often at the emotional expense of the individuals that make up that society. When a society as a whole feels no shame in committing genocide, the individuals that make up that society have to a large degree lost the ability to feel shame in committing horrendous acts of violence. For instance the German population under Hitler or the Guatemalan Ladino population under Rios Montt felt little remorse in torturing and murdering respectively Jewish or Mayan children.

To inhibit the emotional buildup to genocide, what is required are mankind's strongest group inhibitors, a sense of shame and guilt. These painful emotions can be both destructive and constructive. Shame dampens other emotions within an individual. A sense of shame and guilt forces an individual to conform to societal norms overriding other emotions such as love, hate, fear and desire for personal gain that would otherwise dictate individual behavior. Stimulating a strong sense of shame and guilt when violence is used either as a form of pleasure or to resolve conflict, is key. In this manner humanity can control it's own emotional response to the use of violence. Since man is naturally violent, peaceful conflict resolution is a learned behavior. If violence is perceived as a violation of society's norms, shame and guilt can serve as emotional brakes that can prevent genocide from happening more frequently than it does.

Self-confidence promotes human action while shame inhibits it. Excess of self-confidence is rarely treated as an individual psychiatric disorder. That is because excess of self-confidence is not seen as a weakness. Few individuals would desire to have their personal self-confidence lowered to benefit those around them. Those committing genocide are confident in their actions and essentially shameless and guiltless. Extreme self-assurance leads to ruthless behavior in both groups and individuals. Genocide is an extreme form of group excitement that overrides an individual's sense of morality and

Opposite: Rendition of ancient Mayan illustration by Mario Leon Cortez

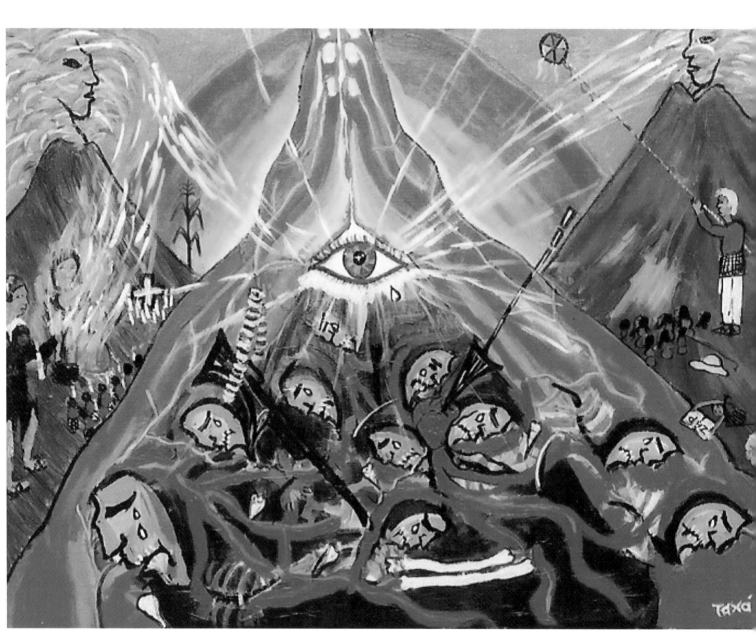

"War and Peace" by Tax'a Leon in acrylic paint.

numbs any shame or guilt in committing evil. Shame can be used as an inhibitor of individual and group excitement that can lead to violence. Shame and guilt are not recognized as emotions that can benefit society as well as harm it and self-confidence is not seen as an emotion that has the potential to lead both individuals and groups to destroy without reflection. When a society's pendulum between shame and feeling grandiose has swung too far towards this blinding extreme self-confidence, the result can be mass murder.

We advocate starting a program of "Global Therapy", where all people, especially children, are instilled with a sense of shame and guilt regarding the use of violence to resolve problems. Equally important, people need to become skilled at alternative forms of conflict resolution. This requires formal long-term training not moral advice or preaching.

Competing against others is seen as appropriate behavior in Western society. A strong emphasis on the need to win by beating other people to achieve success is taught at an early age in Western schools in activities such as sports. The problem with this limited zero sum model is simple, for someone to win someone else must pay the price of losing. The concept of both parties in a conflict coming away winners is not popular in Western culture. Solutions to problems and games where all parties win are rarely taught in Western educational systems or portrayed on television. A course in appropriate conflict resolution and pride in successful collaboration as an alternative to winning should be taught to every man, woman and child on the planet. As long as those that use violence to resolve problems are viewed as heroes and not persons using shameful behavior to achieve their end, violence will continue. Think about who your heroes are and how they resolve conflict. Is violence part of their attraction?

Politicians and diplomats are not the appropriate persons to institute "Global Therapy" since they use whatever means necessary to achieve their goals including war (mass murder justified as being necessary to achieve certain strategic goals). For them, collaboration is viewed as a useful diplomatic tool not an end in itself. A formal professional career in appropriate conflict resolution needs to be established on an international level. At the moment most of the world is lead by politicians and leaders with no real training in conflict resolution, probably the most important skill a leader should possess.

Humanity needs to be shamed on the use of violence on a regular, organized and universal basis. The appropriate use of K'ixb'al is one potential form of global therapy. We realize the ideas in this conclusion may not fit into current intellectual schools of thought regarding conflict resolution. But we hope our book has opened your mind and heart to the reality of being human. All emotions including shame and guilt used wisely can serve the purpose of keeping humanity alive.

Mayan Man

Photo: Douglas London

Trauma and Mental Health

The World Health Organization estimates mental illness affects approximately 10% of the world's population. Other studies put the lifetime figure at about 25% of all humans. Mental disorders are estimated by WHO to account for 12% of the total "global burden of disease" meaning mental disorders surpass almost all other diseases groups in terms of death, disability, and human suffering. Up until recently mental heath disorders had been discounted as having a relatively minor impact on human health and productivity. The reality is that these disorders seriously weaken the family structure, national workforce and country productivity in all nations. Widely successful culturally and economically appropriate mental health treatments have yet to appear in the developing world where the vast majority of the world's 450 million mentally ill live. Creating mental health programs oriented to this majority rather than the small minority in Western nations is a priority. Their only crime is that they are poor and cannot pay for expensive psychiatric providers and medication, mainstays of Western psychiatric medicine. There is no profit motivation to develop appropriate mental health treatments for developing nations. We have witnessed tremendous suffering and death at our clinic everyday but have had great difficulty attracting any interest from the US medical research sector or US funding agencies both of whom are usually less interested in the misery of others far from home. McLean Hospital and Harvard Medical School are making attempts with us to pioneer some of BrainRights programs but few resources are available.

Conventional Western psychiatric treatments have failed to make inroads in most developing nations due to cultural, economic, environmental, political and historical issues as well as the almost complete lack of mental health infrastructure in these regions. Neuropsychiatric programs are often bottom on the priority list of Ministries of Health in the developing world.

Most developing nations lack providers trained in Western psychiatry. Even in the few urban areas where there are some qualified mental health practitioners, the price of continuing follow-up mental health provider appointments that are critical to insure medication compliance, safety and correct dosage, are beyond the financial means of these poverty stricken populations. The same holds true for the extended visits required for western style psychotherapy. There is also a severe shortage or complete lack of inpatient hospital facilities. The lack of acceptance of Western medicine in many regions of the developing world, along with a confidence in indigenous explanations for mental illness, also create cultural barriers to typical Western psychiatric interventions. The fear, shame and stigma surrounding a psychiatric diagnosis cause patients and their families to avoid a visit to a mental health practitioner. The same feelings cause some developing world government officials and doctors to deny the existence of mental illness in their countries.

The above mentioned barriers make it unlikely that Western style psychiatry as practiced in developed countries will make any significant impact in the developing world. A mental health intervention needs to mesh with the preventatively oriented, more cost–effective system found in the developing world while avoiding cultural barriers and stigmatization of the patient. These types of public health measures to confront mental illness are missing in the developing world.

We founded BrainRights of the Americas to make a contribution towards improving mental health services in Latin America. Both Tax'a and I are dedicated to personally making a more lasting impact on the psyches of those suffering in the developing world. We are working through BrainRights of the Americas to begin to promote practical solutions to mental trauma and disease in Latin America. BrainRights for the Americas Inc. is a 501 (c) 3 charity recognized by the IRS and United States government.

I am a research associate at McLean Hospital, which is the largest teaching psychiatric hospital of Harvard Medical School. I am also on the faculty of Harvard Medical School. However, unlike most of my colleagues I am rarely in the USA.

I and my staff at "Clinica Internacional para la Ansiedad", the neuropsychiatric clinic I founded in Guatemala, train Central American doctors and medical staff, treat patients and examine how Western psychiatric medicine may best be adapted to a developing world population.

Our clinic is essentially a bridge between two distinct worlds, the world of Western psychiatry and the world of traditional indigenous medical systems, one a reality to the West and the other a reality to the vast majority of the world's population. Both of these worlds need to come together to develop successful mental health programs in developing countries. Our work will help build bridges to connect isolated mental health programs in poverty stricken nations with neuroscience research and practical program innovations in more developed countries.

BrainRights seeks to work within the cultural and economic systems of Latin America, not to impose a medical system that was never intended for use in a developing world environment. Medical solutions need to be adapted to the realities into which they will be placed into use. We work towards the design and implementation of psychiatric treatments more appropriate for the developing world regions.

We believe the people in the developing regions have as much to teach us as we have to teach them. We are developing programs that will allow for an exchange of human knowledge, understanding and skills between practitioners at all levels, as well as research that focuses on solutions to brain disorders in the developing world.

Over the past few years in our Guatemalan clinic we have seen a range of mental disorders. The most common disorders seen on a regular basis were mental illnesses also common in the United States and other developed countries. What was striking was the high percentage of patients with symptoms of Post Traumatic Stress Disorder (PTSD) and patients with PTSD symptoms alongside other underlying disorders. The PTSD symptoms, so commonly seen in patients at our clinic, often have connections to the Mayan genocide.

In a genocide, humiliation, fear and helplessness penetrate and overwhelm the survivors' mental barriers that normally protect their sanity. All of their senses and emotions are invaded and over stimulated. Eventually, if the traumatic experiences are severe and long-lasting enough, a sort of psychic cancer forms becoming a permanent if unwanted part of their mind and soul. This condition is often referred to as Post Traumatic Stress Disorder (PTSD). Within a reign of political terror, the very culture itself can become traumatized if its population suffers a societal trauma as intense, widespread and extended as the Maya have experienced. Sealed lips and efforts to bury these memories offer illusory protection. But often these tortured souls find no relief as thoughts of panic, fear and helplessness race on, even in cases where peace and prosperity have returned and the perpetrators are long gone. Sadly, in the case of the Maya, the perpetrators have not gone away.

We have found some new treatments that seem to be especially helpful to those with PTSD. We believe our PTSD research in Guatemala will benefit those that suffer from PTSD everywhere. The art and testimonies in this book are often an expression of the echo of PTSD that has lasted to this day.

Trauma keeps the Maya silent when communication is so badly needed.

BrainRights for the Americas, Inc

The Maya need international help. This book gives you the Mayan story. It is up to the readers to decide if they want to get personally involved. The Maya and the poor in the developing world have little recourse to treatment for trauma and mental illness. BrainRights for the Americas, Inc. is a 501 (c)(3) charity recognized by the Internal Revenue Service. This means that contributions are tax-deductible as allowed by law on federal and usually state tax returns for most U.S. donors. BrainRights is a qualified charitable non-profit organization, unaffiliated with any political or religious group. For those interested in making a difference and learning how you can contribute, visit the BrainRights website: brainrights.info

Art for Peace

Art for Peace is a program of BrainRights for the Americas. For those interested in the Art for Peace program, prints of the artwork in "We Were Taught to Plant Corn Not to Kill" and other artwork by Tax'a, visit Tax'a's website: mayanflamegallery.com

The Mayan Flame Art Gallery offer businesses and corporations customized Mayan illustrations for their literature or television programming that demonstrates commitment to peace and health for all cultures. We also design book covers for all topics. If you want impressive book covers (like the one on this book) that will make your book stand out, contact us.

The Gallery also offer libraries, universities, schools, corporations, businesses, museums and individuals the opportunity to have a large Art for Peace mural or painting especially designed for the wall of their institution or home.

The Itzat Maya Academy

The Itzat Maya Academy is dedicated to preserving Mayan culture through the training of young Mayan artists, service to the Mayan community and opening the doors of Mayan spirituality to other cultures. Programs in the pine filled mountains of Chichicastenango, Guatemala, the cultural center of the K'iche' Maya nation are available to serious international students. The K'iche' Maya are a closed society that has just survived a genocide. The academy believes opening the Mayan world to outsiders is essential for the culture's survival. However great cultural sensitivity on the part of the student is required. A letter explaining your interest in pursuing Mayan spiritual studies is required for consideration for acceptance into the program. Visit mayanflamegallery.com or brainrights.info for information.

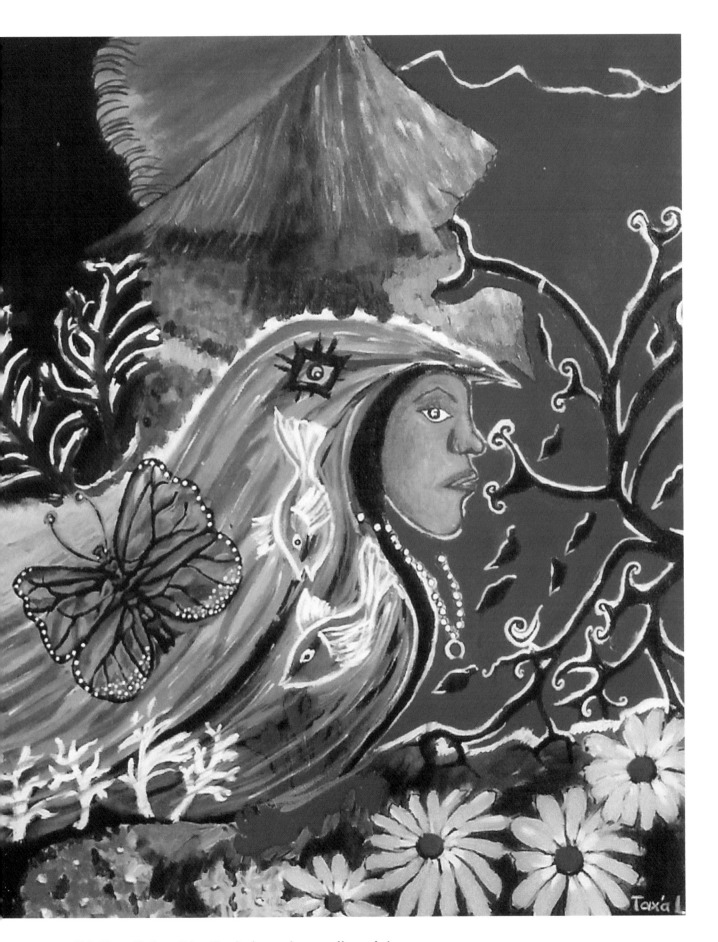

"Mother Nature" by Tax'a Leon in acrylic paint

ART AS A TOOL FOR PEACE

As you've no doubt noticed from reading other parts the book, one of the principal themes in our book is the importance of retaining memory in a form that can transcend the prejudices that come with using a written language. This is especially important in a country with a large illiterate population such as Guatemala. Art is present in all societies and cultures and transmits a strong message that is passed to each new generation that views the artwork. Successful art transcends the image produced and becomes a symbolic unconscious message. In this book we have used art to preserve the memory of an ongoing tragedy with the hope that history will not repeat itself if the memory is kept alive through art.

The power of art and symbolism has not been lost to the advertising world, which recognizes that visual art and the accompanying symbolism cause powerful emotional and attitudinal changes that alter behavior and create desires for change, in this case to buy products and services. Art has uses beyond artistic expression and selling products and services. Art can be used as a tool to promote important causes, positive messages and as a catalyst for changes in a community and society. Art is an under utilized tool in the hands of those promoting peace, health and harmony. Human beings seem to be able to retain symbolism and associated emotions better through art than the written word. Much of the world's population is illiterate or literate in only one language (such as much of the population in the USA). All cultures and linguistic groups can understand artwork. Symbolic art has the power to affect emotions, bypass conscious barriers and create change within an individual. We hope that the memories and art in this book have changed your heart a little.

Below: "United in Peace" by Tax'a' Leon in acrylic paint

FURTHER READING

ON NUTRITION AND MENTAL HEALTH

Douglas London, Andrew Stoll and Bruce Manning. *Psychiatric Agriculture: Systemic Nutritional Modification and Mental Health in the Developing World.* Medical Hypotheses (2006) 66, 1234-39

Cohen, Alex and Kleinman, Arthur and Saraceno, Benedetto. *"World Mental Health Casebook: Social and Mental Health Programs in Low Income Countries".* (Kluwer Academic/Plenum Publishers, 2002)

Murthy RS, Bertolote JM, Epping-Jordan J, Funk M, Prentice T, Saraceno B, Saxena S. *"The World Health Report: 2001: Mental Health: New Understanding, New Hope".* Geneva: World Health Organization, 2001

Eaton SB, Konner M. Paleolithic nutrition: a consideration of its nature and current implications. *N Engl J Med* 1985; **312**: 283-90

Hibbeln JR, Nieminen LR, Lands WE. Increasing homicide rates and linoleic acid consumption among five Western countries, 1961-2000. *Lipids* 2004; **39**:1207-13

Leaf A, Weber PC. A New Era for Science in Nutrition. *Am J Clin Nutr.* 1987;45:5: 1048-53

Murray CJ, Lopez AD. Alternate projections of mortality and disability by cause 1990-2020: The Global Burden of Disease Study. *Lancet* 1997; **349**: 1498-1504

Murray CJ, Lopez AD. Global mortality, disability and the contribution of risk factors: Global Burden of Disease Study. *Lancet* 1997; **349**: 1436–37

Peet M, Stokes C. Omega-3 fatty acids in the treatment of psychiatric disorders. *Drugs* 2005; **65**: 1051-59

Rudin DO. The dominant diseases of modernized societies as omega-3 essential fatty acid deficiencies. *Med Hypotheses* 1982; **8:** 17-48

ON CONFLICT RESOLUTION

Armon J, Sieder R, and Wilson R. Eds. "Negotiating Rights: The Guatemalan Peace Process." *Accord Issue 2. London: Conciliation resources, 1997*

Fisher, Roger and Shapiro, Dan. *"Beyond Reason: Using Emotions as you Negotiate".* (Viking Adult, 2005)

Fisher, Roger and Ury, William. *"Getting to Yes: Negotiating Agreement without Giving In".* (Penguin Books, 1991)

Goleman, Daniel. *"Emotional Intelligence"* (Bantam, 1995)

ON RELEVANT WORLD HISTORY

Diamond, Jared. *Guns, Germs and Steel: The Fates of Human Societies.* (Norton & Co., 1997)

Diamond, Jared. *Collapse: How Societies Choose to Fail or Succeed.* (Viking Adult, 2004)

ON GUATEMALAN CULTURE, POLITICS AND HISTORY

Archdiocese of Guatemala. *"Never Again!"* (Orbis Books, 1999) Guatemalan government assassins murdered Bishop Gerardi the author of this book detailing the atrocities committed by the Guatemalan military, immediately after its publication.

Asturias MA, *"Men of Maize"*. (Verso 1994) Fiction by Guatemalan author.

De Landa, Diego. *"Yucatan Before and After Conquest"*. (Dover Publications, 1978) Written by Bishop De Landa in colonial era, De Landa was one of the principal architects of destruction of the Mayan cultural heritage.

Gillin, John. *"San Luis Jilotepeque"*. (Editorial de Ministerio de Educacion Publica, Guatemala, 1958) In Spanish.

Gleijeses P. *"Shattered Hope: The Guatemalan Revolution and the United States 1944-1954"*. (Princeton, 1991)

Goldman, Francisco. *"The Long Night of White Chickens"*. (Grove Press, 1998) Fiction.

Manz, Beatriz. *"Paradise in Ashes: A Guatemalan Journey of Courage, Terror and Hope"*. (California Series in Public Anthropology, 2005)

McClintlock M. *"The American Connection: State Terror and Popular Resistance in Guatemala"*. (Zed Books, 1985)

McSherry, JP. *"Predatory States: Operation Condor and the Covert War in Latin America"*. (Rowman and Littlefield, 2005)

Menchu, Rigoberta et al. *"I, Rigoberta Menchu: An Indian Women in Guatemala"*. (Verso 1987)

Montejo V. *"Death of a Guatemalan Village"*. (Curbstone Press, 1987)

O'Kane, Trish. *"Guatemala in Focus: A Guide to the People, Politics and Culture"*. (Interlink Books 2000)

Sandoval, Victor. *"Pequena Monografia de San Luis Jilotepeque"*. (Centro Editorial " Jose de Pineda Ibarra" Ministerio de Educacion, Guatemala, 1965)

Sanford, Victoria. *"Buried Secrets: Truth and Human Rights in Guatemala"*. (Palgrave Macmillan, 2004)

Schlesinger S. and Kinzer S. *"Bitter Fruit: The Untold Story of the American Coup in Guatemala"*. (Doubleday/Sinclair Browne, 1982)

Simon, JM. *"Guatemala: Eternal Spring, Eternal Tyranny"*. (Norton UK & US, 1987)

Wilkinson, Daniel. *"Silence on the Mountain: Stories of Terror, Betrayal and Forgetting in Guatemala"*. (Houghton Mifflin, 2002)

ON ANCIENT MAYAN ART AND ARCHEOLOGY

Aimi, Antonio. *"ArtBook Mesoamerica: Olmecas, Mayas, Aztecas: Las Grandes Civilizaciones del Nuevo Mundo"*. (Electa Bolsillo-Random House, 2003)

Brenner, Mark et al. "Paleolimnology of the Mayan Lowlands: Long-term perspectives on interactions among climate, environment and humans". *Ancient Mesoamerica* (2002) 13:141-157

Coe, Michael D. and Van Stone, Mark. *"Reading the Maya Glyphs, 2nd ed."* (Thames and Hudson, 2005)

Coe, Michael. *"The Maya, 6th ed."* (Thames and Hudsen, 1999)

Coe, Michael. *Breaking the Mayan Code.* (Thames and Hudson, 1999)

Curtis, Jason et al. "A multi-proxy study of Holocene environmental change in the Maya lowlands of Peten, Guatemala" *Journal of Paleoelimnology* (1998) 19:139-159

Curtis, Jason et al. "Climate variability of the Yucatan Peninsula during the past 3500 years and implications for Mayan cultural evolution". *Quaternary Research* (1996) 46:37-47

Demerset, Arthur & Rice, Prudence & Rice, Don eds. *"The Terminal Classic in the Mayan Lowlands"* (University Press of Colorado, 2004)

Freidel, David and Schele, Linda. *"A Forest of Kings: The Untold Story of the Ancient Maya"*. (Harper Perennial, 1992)

Gill, Richardson. *"The Great Maya Droughts"* (University of New Mexico Press, 2002)

Hodell, David et al. "Solar forcing of draught frequency in the Maya lowlands". *Science* (2001) 292:1367-1370

Lucero, Lisa "The collapse of the classic Maya: a case for the role of water control" (2002) *American Anthropologist* 104:814-826

Miller, Mary Ellen. *The Murals of Bonampak*. (Princeton University Press, 1986)

Rosenmeier, Michael. "A 4,000 year lacustrine record of environmental change in the Mayan lowlands, Peten, Guatemala". *Quaternary Research* (2002) 57:183-190

Schele, Linda & Miller, Mary Ellen. *"Blood of Kings: Dynasty and Ritual in Maya Art"*. (George Braziller/Kimbell Art Museum, 1986)

Schele, Linda et al. *"Code of Kings: The Language of Seven Sacred Mayan Temples and Tombs"*. (Scribner 1999)

Tedlock, Dennis. *"Popol Vuh: The Definitive Edition of the Mayan Book of the Dawn of Life..."*. (Touchstone, 1996)

Webster, David. *"The Fall of the Ancient Maya"* (Thames and Hudson, 2002)

ON MODERN MAYAN CULTURE AND RELIGION

Barrios, Carlos *"Ch'umilal Wuj: El Libro del Destino"* (CHOLSAMAJ, Guatemala, 2004) In Spanish, excellent book about modern Mayan religion and use of nawals.

Tedlock, Barbara. *"Time and the Highland Maya"*. (Univ. New Mexico Press, 1992)

Alvarado Walburga, Rupflin. El Tzolquin es mas que un Calendario. (Fundacion CEDIM, Guatemala, 1997)

Acercamiento a la Interpretacion del Cholq'ij. (Centro de Desarrollo y Ciencia Maya KEMATZIJ, 1999)

Bunzel, Ruth. Chichicastenango. (Seminario de Integracion Social Guatemala, Jose de Pineda Ibarra, Guatemala, 1981)

Espinoza Villatoro, Erik. Rejqalem ri Wa'ix, Demension Cero, (CHOLSAMAJ, Guatemala, 1999)

Medina, Tito. El Libro de la Cuenta de los Nawuales, (Fundacion CEDIM, Guatemala, 2000)

Upuc Sipac, Damian. Maya' Ajilab'al Q'ij, La Cuenta Maya de los Dias. (CHOLSAMAJ, Guatemala, 1999)

Authors

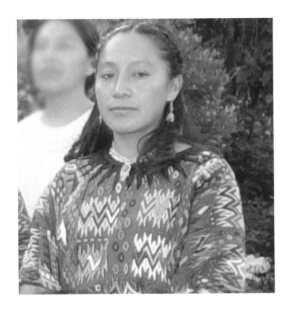

Tax'a Leon is a Maya human rights worker, artist and law student. She grew up with 12 brothers and sisters in a small K'iche' Maya village in the department of Quiche, Guatemala. She is a native K'iche' speaker and learned Spanish when she was fourteen years old. She recently immigrated to the United States and lives with her husband Douglas.

Douglas London has worked nine years in Guatemala where he founded and directed a mental health clinic to develop culturally appropriate mental health treatments for developing nations. He has worked in developing nations around the world. He has a degree in public health from Johns Hopkins University and a degree in International Education from Columbia University. He is a researcher at McLean Hospital and on the Faculty of Medicine at Harvard University. London is an expert in international mental health.

Photos by Douglas London and Tax'a Leon

Printed in the United States
144515LV00002B